The River Thames
in London

Barking

WAPPING

Blackwall

ESSEX

Rotherhithe
Bermondsey

Woolwich

Deptford

Erith

Greenwich

O

N

KENT

THE WAPPING GROUP OF ARTISTS

Published 2005 by

Seafarer Books · 102 Redwald Road · Rendlesham · Suffolk IP12 2TE · England
UK ISBN 0-9547062-5-0
Sheridan House Inc · 145 Palisade Street · Dobbs Ferry NY 10522 · USA
US ISBN 1-57409-218-9

A CIP record for this book in the UK is available from the British Library
A CIP record for this book in the USA is available from the Library of Congress

Text set digitally in Proforma
Design and typesetting by Louis Mackay
Copy-editing by Hugh Brazier
Printed in China on behalf of Compass Press Ltd

SEAFARER BOOKS SHERIDAN HOUSE

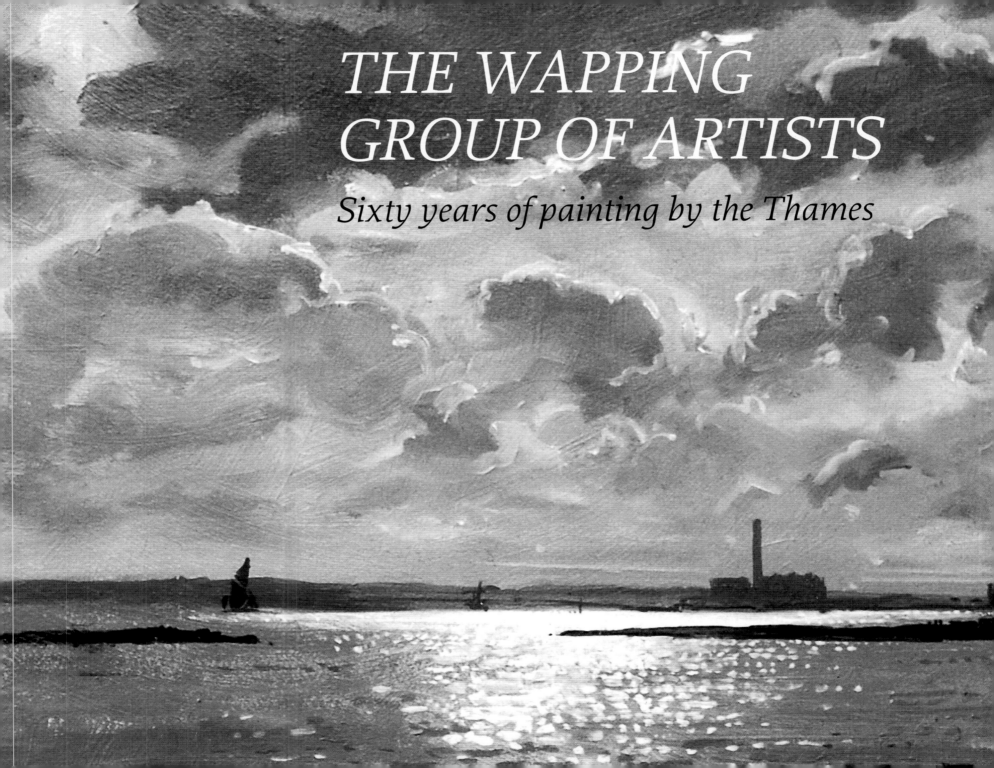

THE WAPPING GROUP OF ARTISTS

Sixty years of painting by the Thames

This book is dedicated

To past members of the Wapping Group
— may it be a worthy tribute to them and their work.

And to Pat Jobson, founder member and present member
— and still the mainstay of our group.

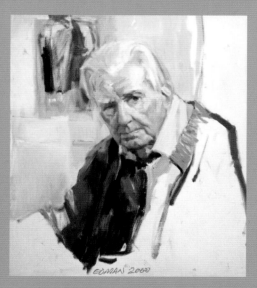

Portrait of Pat Jobson by Edman O'Aivazian

Contents

Acknowledgements

With thanks to the members of the Book Working Group – Geoff Hunt, Paul Banning, David Penny and Bill Davies – and to Jeanne Penny, for all their work in compiling this volume; to Robin Mackervoy, for the portrait sketches on page 31; to Denis Pannett for updating the Group's history; and to all who contributed.

The 'Wappers' would also like to thank our publisher, Patricia Eve, for her enthusiastic and steadfast commitment to this book; and our patient and understanding designer, Louis Mackay.

Foreword

The Wapping Group is the last proper artists' society left in England. The rest are but loose associations of exhibiting artists who meet rarely if ever at intermittent exhibition time; who collide but briefly on sending-in day; who occasionally jostle uneasily in selecting fellow members at election time. A sense of confraternity has been lost amongst those predictable aggregations of strangers, who are identified as members of a group only by the letters after their name and the gentle cloning of their art, as envy and uncertainty direct them to adopt the style and mannerisms of the most successful artist.

Not so the Wapping Group, that still continues to vigorously reinvent itself in the traditional artists' way; to meet, to greet, to paint together, eat together, to talk, argue, criticise and discuss, to learn and earn.

Artists are better for mingling, they are improved by shared experience even if it seems so subtle as to be imperceptible to measurement. For the Wapping Group it is perhaps symbolised with jolly banality by that first convivial drink at the pub after a cold afternoon on the Thames.

Now, do not think of the Wappers as a laddish group of daubers who need an excuse to go the pub without their wives, or a bunch of Sunday splashers who need collective reassurance in the respite hours from the office job. No, this is serious professional group who are bound together for their spiritual and technical advancement and, yes, have a good time on the way.

Too great a claim? Well, think back to a group with wider concerns than the Thames and who are art-historically more celebrated – the founder members of the London Sketch Club. It is inconceivable that the likes of the Beggarstaff Brothers (Pryde and Nicholson), John Hassall, Cecil Aldin, H. M. Bateman, Heath Robinson and Tom Browne, in changing the look of twentieth-century illustration and advertising, did not get part of their inspiration from the weekly set subject, hot supper and high-spirited smokers and theatricals.

As the Wapping Group line up on the bank of the most fascinating river in the world there is on display a variety of styles and talents. Technique and application vary wildly and though all artists are confronting the same subject their aims and approach differ interestingly. Some are poets, mood men searching out the misty atmospherics of dawn and sunset, rain and sun. Others the tideway technocrats, who know every knot and splinter of the boat, sailors at heart who could be aboard with ease and log the joggle shackle, dob the gobsticks and abeam the futtocks with the best of them.

The results are an ever-changing celebration of an ever-changing stretch of river whose beautiful elemental force divides our man-made city.

Like the Wapping Group, my West End gallery also has traditional aims rooted in the art of the natural world. Remaining faithful to this art, the Wappers have prospered for sixty years. I wish them well for the next sixty.

Chris Beetles
June 2005

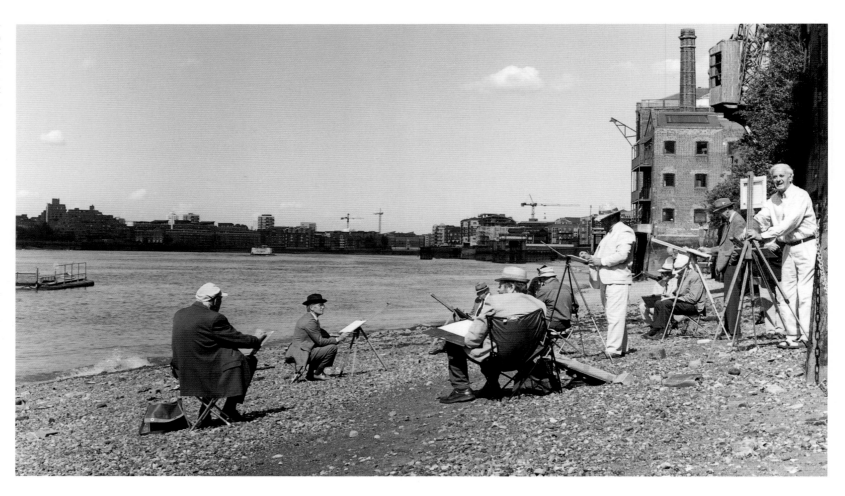

Wapping Group artists painting at Rotherhithe in 2001; current President, Bill Davies, at extreme right.

Introduction

This book is a welcome opportunity to look back over the first sixty years of the Wapping Group of Artists, as well as to celebrate the work of its current members.

Since being established in 1946, the artists of the Wapping Group have carried on their work, observing and painting London's river. The natural, challenging and exciting changes in this landscape, not only over six decades, but indeed from week to week, have been recorded from individual perspectives and are well illustrated in these pages.

We were founded to be an artists' society – to meet together each week because we enjoyed each others' company, to paint together in companionable fellowship and encouragement, and to enjoy a pint at the pub afterwards. I believe our new book conveys much of this essential nature of the Wapping Group; this is not primarily a history of the Thames seen through artists' eyes, nor just another book about painting, but instead it gives a real feeling of what it is like to be a 'Wapper', and why this group is so special both to our members and to our many friends from around the world.

As current President of the Group, I welcome you on behalf of all our 25 members. We hope you will find our work and thoughts on the challenges of open-air painting interesting and, to those budding painters among you, encouraging.

W. DAVIES.

Bill Davies
President, The Wapping Group of Artists

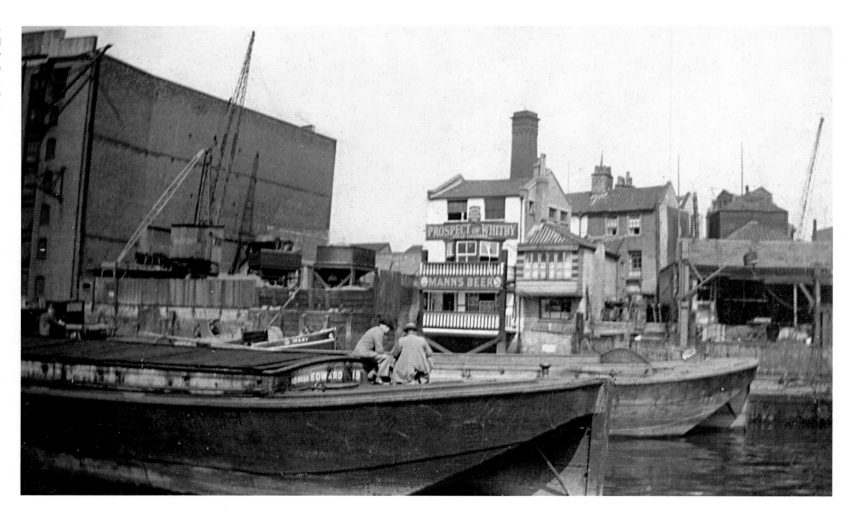

William Watkins and
J. Seymour Lindsay
sketching at the
'Prospect of Whitby',
Wapping, some time
before 1939.

I
Sixty years of painting London and the River Thames

The Wapping Group of Artists must be one of the oldest societies of working painters in the country. It was founded to depict the life of the River Thames, and for sixty years its members have met every week between April and September with that same purpose: to celebrate the River Thames in all its aspects and moods by painting subjects on the spot.

As early as 1938 a group of painters was filmed for a Pathé newsreel titled 'At work down Wapping way' and in 1939 members of the Artists Society and Langham Sketching Club, originally founded in 1830 for the purpose of drawing and painting the human figure, decided to devote the summer months to sketching by the tideway. Here was the opportunity to keep in touch with one another and spend some hours painting together – then, after their creative labours, to relax and chat at the local pub. The Group began as it meant to go on. One day at the 'Prospect of Whitby' pub in Wapping, over a convivial pint, someone said 'we ought to call ourselves the Wapping Group'. Thus the founding group of painters chose as their sketching ground the Thames from the Pool of London down to Blackwall and Rotherhithe.

The founding of the group
The Second World War brought such pleasant activities to a halt, but in 1946, at another meeting of the Langham Sketching Club, the same enthusiasts proposed to take up the idea again. With unanimous and enthusiastic approval, the Wapping Group was officially founded. There were twenty-one founder members, and the maximum membership at any one time was set at twenty-

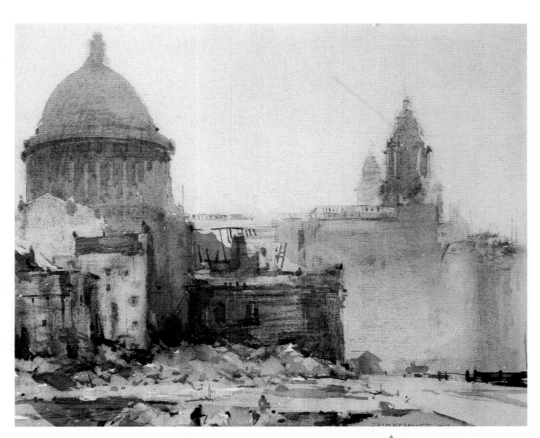

St Paul's after the Blitz. Watercolour, Jack Merriott.

five. Among the leading figures in the beginning were Arthur Burgess, Wilfred Fryer, Jack Merriott, James Middleton, Eric Thorp and William Watkins – all artists of established reputation, many of them senior members of other art societies. The first President was Jack Merriott, and the very eminent artist Sir Frank Brangwyn was

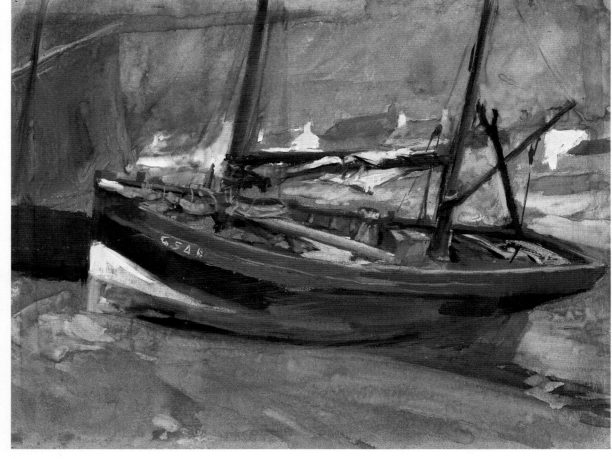

Wednesday afternoons and evenings. From the beginning the whole spirit of the Group revolved around painting together. Exhibitions were a secondary consideration. Originally the programme of riverside venues ranged from Westminster down to Gravesend, mostly between Blackfriars and Woolwich, taking in the docks north and south of the river, with occasional Saturday meetings held at Leigh-on-Sea or Gravesend. (Subsequently the painting limits were to be defined as 'between Teddington Lock and

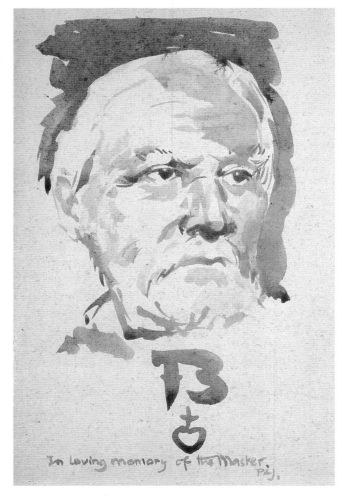

In loving memory of the Master, PeJ.

▶ Pat Jobson sketching at Bankside (*Picture Post*, 16 August 1947). Photo © Hulton Getty

▶▶ Sir Frank Brangwyn. Watercolour portrait by Pat Jobson.

delighted to accept the post of Honorary Vice President.

An inaugural supper was held at the 'Prospect of Whitby' on 16 May 1947, and later in the year the first exhibition took place at the Port of London Authority headquarters on Tower Hill, by kind permission of Sir John Anderson, then Chairman of the PLA. Opened by the writer A. P. Herbert, the exhibition brought the Group to public notice and enjoyed much support from shipping and marine insurance interests in the City; it was also reported in a special article in the *Picture Post* issue of 16 August 1947. The Group was firmly established and has never looked back. At some time, certainly as early as 1947 or 1948, a nickname appeared. We were 'the Wappers'.

Then as now, the weekly meetings took place on

the Nore Lightship'.)

Blackfriars to Woolwich might not seem like a wide area of operation, but in the 1940s and 1950s the River Thames up to and beyond Tower Bridge was still a commercial highway, and there was an enormous amount to study. In those days before containerisation, merchant ships from all parts of the world lay at moorings in the stream surrounded by barges and lighters, or alongside the wharves on either bank of the river and in the vast docks. A happy association with the Port of London Authority allowed Group members access to the docks where the larger vessels lay beneath the great travelling cranes. Swarms of steam tugs handled the big ships in the confined waterway. Sailing barges still worked the length of the tidal Thames, up into the Essex rivers and along the north Kent coast. Now and then a square-rigged sailing ship was still to be seen. Atmosphere was added to this thriving commercial scene by fog, mist off the water and smoke and steam from the ships. To members of the Wapping Group, with their natural affinity for ships and boats, for the restless tide and the men at work, it was truly inspirational.

The Group's logo, very evocative of its origins beside a working waterway, was an early creation, and the now-familiar design combining the tug and artist's palette was conceived by F. C. Winby. He also began to assemble and keep the *Annals*, the very personal as well as factual record of the Group's activites, in which have appeared so many notes and humorous sketches by the members. This pleasurable task was subsequently taken over by Pat Jobson, followed by Charles Smith. It is now in the hands of Roger Dellar.

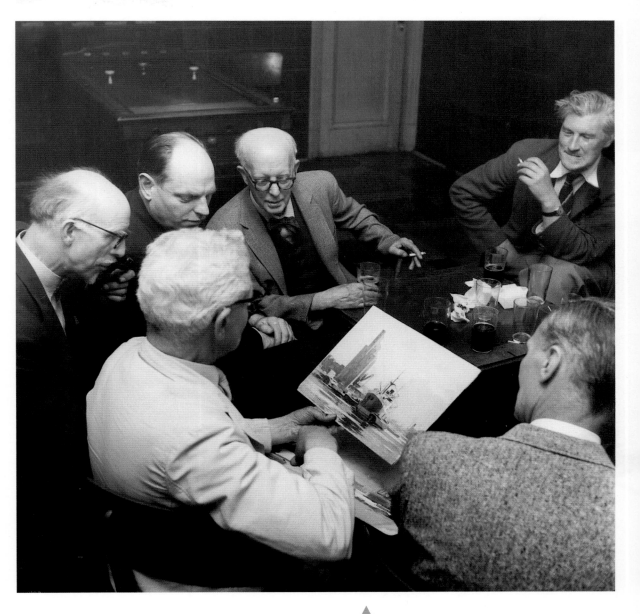

▲ Wappers of 1959 in a typical setting. Clockwise from top right: Hugh Boycott Brown, John Wheeler, Wilfred Fryer (holding the painting), Eric Thorp, James Middleton and Leslie Ford. Photo ©Desmond O'Neill.

◄◄◄ The WGA logo, designed by F. C. Winby.

The fifties

1950 saw the need for repairs to the Port of London Authority headquarters building, which had been damaged during the war, and so the Wapping Group was obliged to seek another venue for its annual exhibition. Through the good offices of the Gresham Committee, a

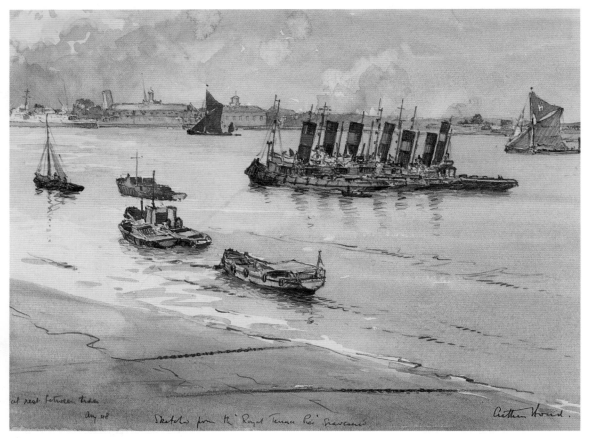

▲
Sketch from the Royal Terrace Pier,
Gravesend. Watercolour by Arthur Bond

new home was found at the Royal Exchange, where the annual exhibition was to remain for the next thirty years. There, in the heart of the City, the Group enjoyed a venue which was a favourite lunchtime gathering place. The exhibition screens were arranged all round the spacious ground floor of the Exchange, lit by the vast glass roof. It was possible to display some two hundred paintings at a time, and a hanging system was developed which has lasted to this day. Each artist was allotted two screens on which to arrange his own group of paintings.

In 1955, in addition to the annual exhibition, the Wapping Group was invited to mount a special show at

the Geffrye Museum in Bethnal Green; while in August 1956 the film newsreel *Pathé Pictorial* again featured the Group in cinemas around the country. Some years earlier, in 1948, Arthur Bond had established a studio on Gravesend Pier in the same building used by the Thames river pilots. During 1956 this pier-head studio became the setting for a number of invited meetings where members could chat to many of the pilots. It was also at this time that the Whitebait Suppers were introduced, which now traditionally begin and end each year's painting season. The first suppers were held at the Clarendon Hotel in Gravesend. A further innovation was the annual Ladies' Night Dinner, which has developed traditions all of its own.

The sixties and seventies

The 1960s and 1970s saw great changes in the character of the Thames. Much of the cargo trade moved away from the centre of London, downstream to Tilbury and Harwich. The growth of bulk carriers, containerisation and the corresponding increase in lorry traffic meant the greater use of the roads and a decline of the commercial trade on the tideway. Sailing barges ceased to be cargo carriers and became pleasure craft, although they still kept their traditional rig; and steam tugs were replaced by diesel. The waterborne funeral procession of Sir Winston Churchill in 1965 was marked by the dipping of the jibs

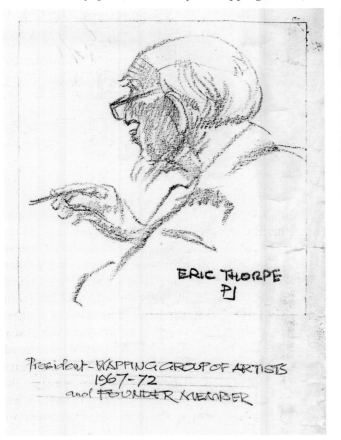

ERIC THORPE
PI

President WAPPING GROUP OF ARTISTS
1967-72
and FOUNDER MEMBER

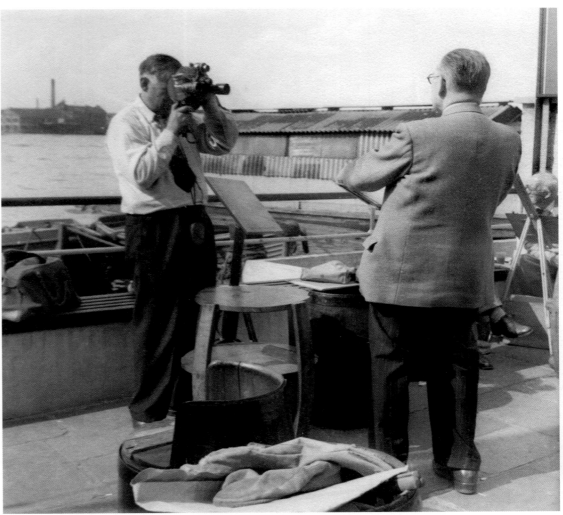

▲ Pathé News filming the Wapping group, 1956

on the giant waterside cranes, lowered in salute as the coffin was carried up the Thames; it symbolised the end of an era for Dockland as well as for Churchill's generation. London's wharves were to close, the great cranes were to disappear. For this reason it was decided that the Wapping Group should broaden its patch, extending to the uppermost reaches of the Thames and further downstream; and, ranging further from the riverbank itself, the City of London was also to be included. By this time, too, many more members owned cars and this enabled painting expeditions to be made further afield, eventually

◄◄ Sketch by Pat Jobson

The last twenty-five years

The Group's long association with the Royal Exchange ended in 1980. Building alterations were again the cause of the move. Then in 1981, through the good offices of Betty Jobson, a meeting was arranged with the Reverend Malcolm Johnson, Rector of St Botolph's church, Aldgate. Thanks to his sympathetic attitude and that of his Churchwardens, the Group thenceforth staged the annual exhibition in this magnificent City church. But in St Botolph's it was no longer possible to display so many paintings at one time, so the practice began of exhibiting four paintings by each member for the first fortnight, following which an entirely new exhibition was hung for a further two weeks.

The Group's reputation continued to grow, and in 1985 and 1987 it was invited to stage exhibitions at the Royal Festival Hall, and in 1986 at the National Maritime Museum, Greenwich. Further invitational exhibitions followed at the Fine Art Gallery, Devonshire Street; the David Curzon Gallery; the Hallam Gallery; and at locations in Amersham, Berkhamsted, Chichester, Gomshall and Datchet.

The Museum of London's 'Docklands Project' recorded a series of interviews in which Pat Jobson, as a founder member, spoke of his memories of the river and the 'Wappers'.

In 1995 an exhibition was mounted at All Hallows by the Tower, while 1997 to 2000 saw further exhibitions at the City Gallery in London, then in 2001 at the Henley Regatta and Rowing Museum. To commemorate fifty unbroken years, the Group published its first book (also titled *The Wapping Group of Artists*) in 1996, which was launched at an exhibition at the Chris Beetles Gallery in the West End. Then in 1999 the Group broke fresh ground with the first of several overseas painting trips. This, to Honfleur, was followed by trips to Bruges, the Loire Valley, Amsterdam, Normandy and Picardy. These proved most successful and partners often accompanied the artists, as

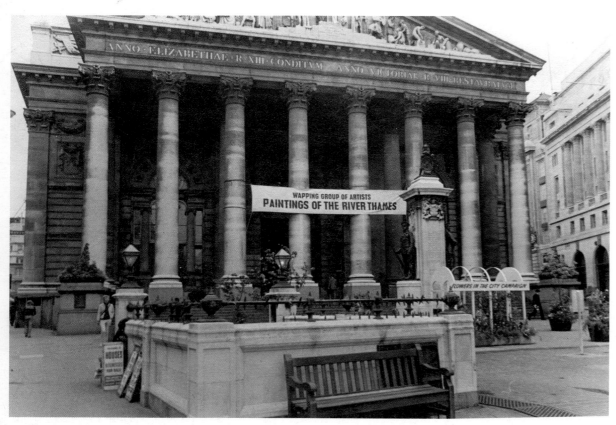

▲ The 1971 exhibition at the Royal Exchange

extending the range of locations up river as far as Windsor and down river to take in the estuary as far as the rivers Medway, Orwell and Blackwater.

In 1971 a special twenty-fifth annual exhibition was held at the Royal Exchange, as well as a celebratory exhibition at the Arundel Art Centre. Then in 1972 an exhibition was staged at the Hitchin Museum and Art Gallery. During the late seventies, four exhibitions were held aboard the paddle steamer *Tattershall Castle*, moored on the Thames near Hungerford Bridge. These exhibitions introduced the Group's work to a wider public; visitors were noted from America, Japan and many European countries.

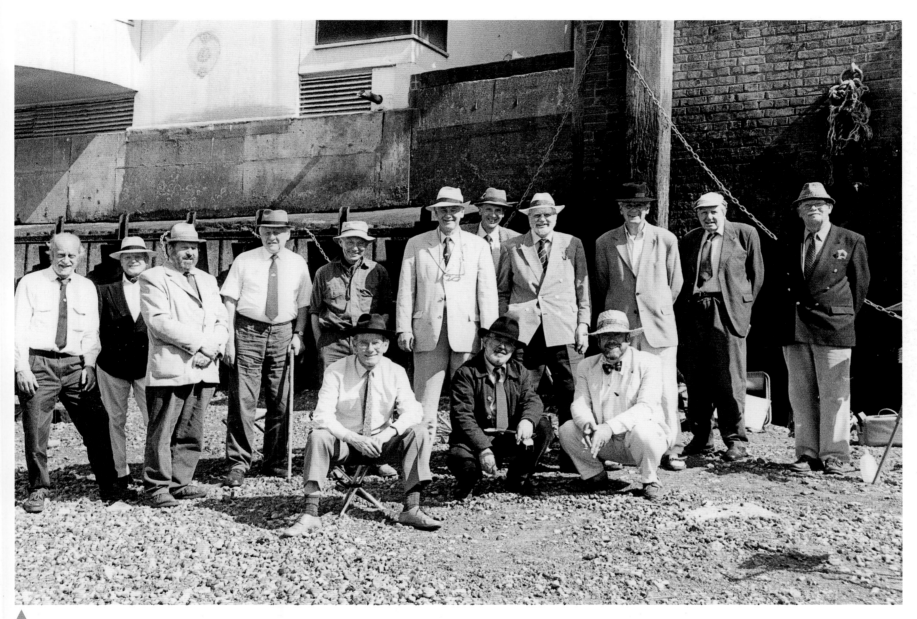

Members of the Group in 2001, dressed in style to commemorate earlier times. Standing, L to R: David Penny, Roy Hammond, John Worsdale, Robin Mackervoy, John Powley, Roger Dellar, David Brunwin, David Griffin, Bill Davies, Pat Jobson, Denis Hanceri. Front row, L to R: Alan Runagall, Edman O'Aivazian, Mike Richardson.

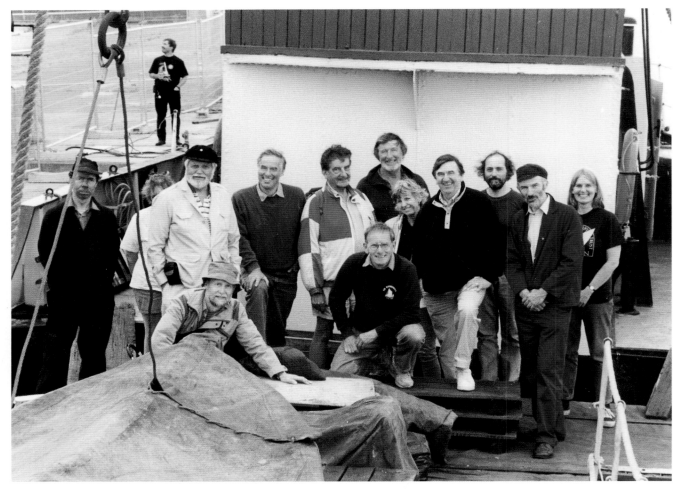

Aboard VIC 56.
Standing, L to R: ship's
crew member, David Griffin,
Denis Pannett, Leonard Bennetts,
Tony Flemming, Carol Runagall,
Fred Beckett, three ship's crew.
Front row, L to R: Grenville
Cottingham, Alan Runagall.

well as fellow painters from outside the Group. Members also enjoyed two memorable trips up the Thames to Tower Bridge in the steamship VIC 56, with the artists at the wheel most of the way!

By 2002 St Botolph's had become less suitable as a venue for the annual exhibition, and this event was moved once more, this time to the Mall Galleries, on the Mall just under Admiralty Arch, where it has remained since.

The place we might call London-on-Thames has changed radically over sixty years – from being one of the nation's greatest ports, through the long decades of the docklands lying derelict, to the glittering transformation of recent years; the return of immense wealth and commerce, though of a different kind. Looking back to the founding days of the Wapping Group is looking at another world, another river. Yet to those who have been long associated with the 'Wappers' – and one of the original founder members, Pat Jobson, is still not only very much

alive but was deeply involved in making this book – to those with long memories, the members themselves are somehow much the same. The names may change, but the Wappers still paint their river with the same dedication and passion. They will still turn out come rain or shine; they are to be found at work where the east wind cuts across the Essex marshes, or where the summer sun blazes on the glass facades of Docklands; they love equally the broad gleaming tideway and the quiet backwater somewhere up-river. And they still like a pint of beer when the day's painting is done.

After sixty years the Wapping Group seems to have become a permanent part of London and its river; after a hundred, we like to think, they will still be here – different names, of course, painting a different kind of river; but still recognisably the Wappers, cursing the day's weather and looking forward to their pint in the evening.

THE SWAMPING GROUP OF ARTISTS

▲
From the 1954 *Annals*.

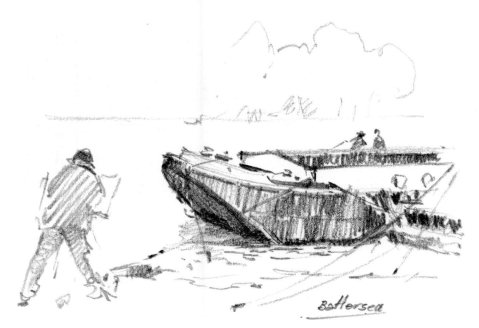

Battersea

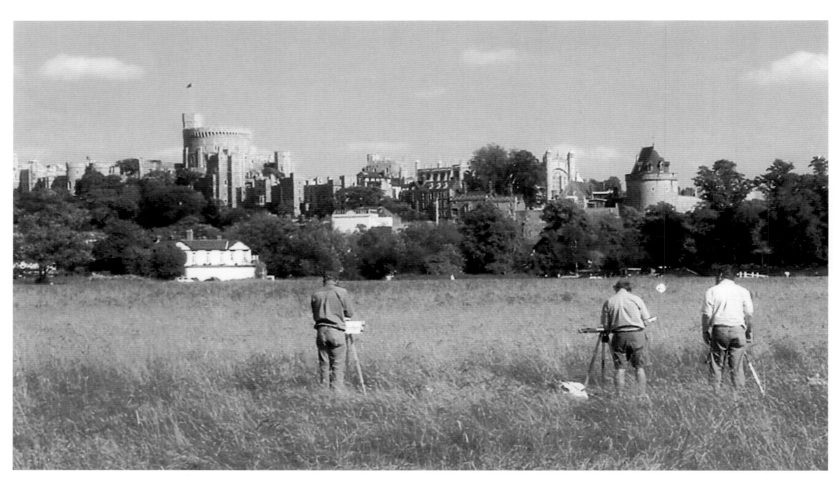

When the sun shines: painting Windsor Castle from Eton meadows, high summer.

II
The pleasures of painting 'plein air'

It must be assumed by most that to paint in a warm studio, with good lighting, constant temperature, access to a loo, and to food and drink as and when required would be the way to create a painting. To some this is the only way to paint. But there are other ways.

It is possible to collect subject matter by using a camera, or a little more demandingly, by sketching. The other way is to paint *en plein air* (outdoors, on location). Now that is a challenge. You will have to take all your equipment with you, easel, paper, paints, brushes, stool, sun cream, hat, warm clothes in the event of a change in the weather, and the weather may not be sunshine all day. The tide comes in and goes out, the sun moves across the sky, shadows change, boats go up and down or, since the river is a working area, they may be moved – either away, if you were painting them, or to obstruct your view if you were not! These become the challenges of the devout plein-air painter.

Plein-air painting is not new. Constable painted many sketches outdoors, as did Turner. There are many stories of Van Gogh painting in the hot Provence sun – or think of Monet with his painting trolley of different canvases for different times of the day, it being wheeled along by his daughter, or of his painting boat moored in the right place to capture that special scene.

The Wapping Group since its inception in 1946 has always been a group of dedicated plein-air painters. Perhaps one of the attractions when thinking of becoming a member is that they paint on a different venue each Wednesday during the summer months somewhere on the Thames.

The start of the season is usually at a venue at one end of the river, say Greenwich, when after painting we meet in a familiar pub and have a whitebait social evening. This gives an opportunity to share some stories and travels over the winter period, and cements the bond of friendship within the Group. The same happens at the end of the season, this time at the other end of the river, say Richmond, and another evening of whitebait, banter, and jokes.

A programme for the summer is prepared, giving each Wednesday's venue, the time of high tide, and a pub to meet for the end of the day. Wappers travel from different parts of the South to meet up for the painting date. It can be pouring with rain when you leave home, but the

◀ Sketch by F. C. Winby from the 1949 *Annals*.

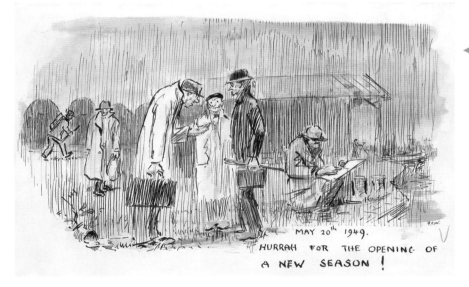

MAY 20th 1949.
HURRAH FOR THE OPENING OF A NEW SEASON !

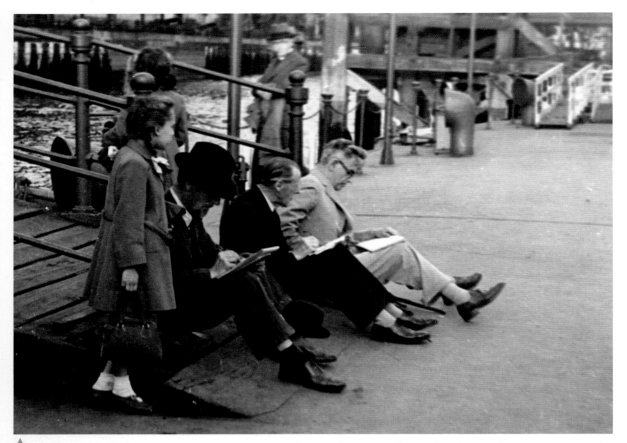

Jack Merriott, F. A. Bell and C. H. Drummond at work under an appraising eye.

the paint is flowing and concentration is essential, you hear 'Are you a real painter, Mister?' They tell you of their uncle or grandmother or sister, who also paint pictures, and your concentration has gone.

Roger Dellar tells one such story. He was painting on the South Bank on the very week that Tate Modern had opened. He was painting the buskers by the bookstall, and every five minutes he was asked, 'Could you direct me to the Tate Modern?' After many interruptions he took to just pointing in the direction of the immense building. He was anxious to finish his painting in case the buskers packed up, so was particularly irritated when a lady came up and said 'Excuse me?' 'What?!', was his irate reply. The lady, flustered, thrust a piece of paper into his hand, and said, 'I have been watching you paint and I really like the picture. I have to go as I have an audition at the National

devout painter will travel miles to the correct venue in order to have an afternoon painting with friends. The weather and the painting are unpredictable enough. But there is also the unknown quantity of encounters with the public

John Powley tells of a conversation with a schoolgirl on her way home from school. The girl had been watching him painting for some time, while telling him various family secrets. She ended the interview by saying, 'Are you going to be an artist when you grow up?'

Artists react to onlookers and public comment and questions in different ways. Some become chameleons, merge into the background and avoid all public contact if possible, while others are happy to have a conversation. But even for the most approachable artist, a break in concentration can be disastrous. Just at that time when

Theatre. If I get the part I would like to buy the painting.' And at that she rushed off. She had left her phone number. When the painting was finished Roger rang her. She had landed a part in *Noises Off*. They met, and she bought the painting. They have since become good friends. The lady now has a leading role in *Coronation Street*.

The public are not the only distractions that the plein-air painter encounters. The Thames and its tides can be notoriously tricky and people can easily be caught out. The banks at Putney, Richmond and Twickenham are particularly vulnerable. Trevor Chamberlain remembers one spring tide at Eel Pie Island. He had parked well up the slope, knowing that a spring tide was expected, and retired to the 'Barmy Arms' for a well-earned drink. On returning he was staggered to see his car with the murky Thames lapping over the door-sills. He managed to bail out the floor wells and was very relieved when the engine started. Not so the brand-new Jaguar further down the slope, which belonged to Charles Smith. The water was halfway up the doors of his car. Charles was seen bailing out the well inside his car with a pint mug. Later he did say that the garage managed to get it going again, but never got rid of the unpleasant smell.

The water's edge can be a risky environment in other

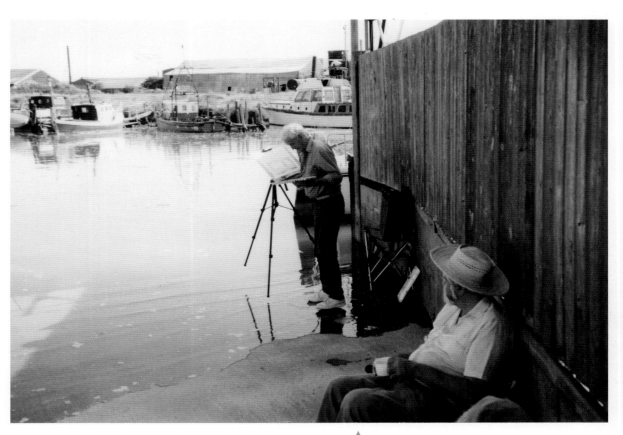

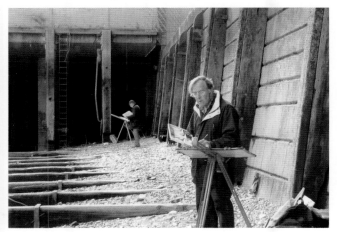

ways. John Worsdale was painting with Sydney Foley, Syd Vale, Bill Davies and Charles Smith, at Rye harbour. The three others all went off for a cup of tea, leaving John on his own. He had just set up on the side of the river with the tide coming in; the wind was gusty, and before he knew it, his easel and board had blown into the drink and were proceeding up the river at a rate of knots. He raced up the harbour, nobody about, so he stripped off down to his underpants and dived in, and with the current taking him upstream diagonally retrieved the easel as it came along on the current. He emerged from the water just as the others returned from their cup of tea. Great amusement to all!

So it can be seen that there are plenty of obstacles to

Perils of the tide. Bill Davies leaves it just a little late to move pitch. David Griffin enjoys the entertainment, along with a cup of tea.

◄◄
David Penny and Paul Banning on the shore at Mansion House steps.

▲ In 1957 members still went straight from their daytime office work to the evening's painting; and no sign of dress-down in evidence. Photo © Desmond O'Neill.

deter the plein-air painter. You have to contend with the public, the tide, and wind and rain (and sometimes glaring sunshine, with dust and flies thrown in as extras) before you can even begin to struggle with the painting.

In earlier days most of the painters worked in the City, and when they finished work they would congregate on the Thames banks from the lower pool to Rotherhithe. They would turn up in their city suits, collars, ties, and hats. It was just after the Second World War, in which many had served for their country. Times were hard, and to go painting after work was a treat. They were a dedicated bunch of chums. There were few cars about and, if you were lucky enough to own one, no parking problems (though you might have trouble getting petrol for it).

The river through the City and eastward was a very busy working area, with steam and smoke from the busy activity of the docks, lighters, tugs, and working craft. A painter had endless subject matter in a very small area. As time went by, so the dockland area changed. The commercial traffic disappeared, the docks shut down, and the warehouses were converted to luxurious flats and apartments. The plein-air painter encountered new and different problems. Access to the river frontage disappeared or became much more difficult, as building sites blocked off roads and footpaths. One had to learn new ways to reach a choice spot, and then where to park. As this transformation changed the river so it changed the area that the group painted. These days, Group members will travel miles to the venue of the day, a round trip for some being as much as 200 miles to get a day's painting. One member has a camper van, and stays overnight so as to obtain a full day's painting. It is obvious that the Wappers have to be dedicated to want to travel so far for a day's painting, but it is done, which shows how keen they are.

In 2004 we were painting at Faversham Creek. There was a notice on the docks saying that the whole dock area

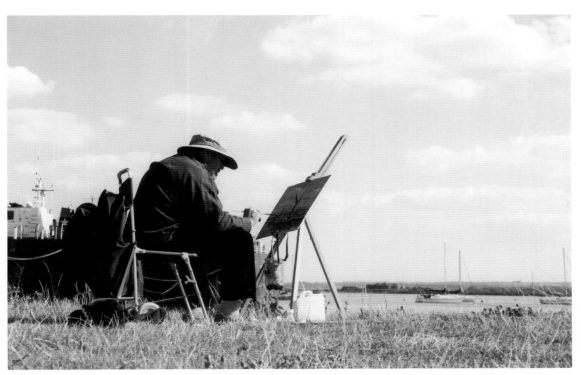

▲ Today's more usual painting attire.

▼ Sketch by David Griffin.

was going to be developed and that signatures were needed to petition against the development. We obliged. The other side of the Creek had already been developed since our previous visit. Three or four of us were painting in this developed area when a lady approached us and said, 'How did you get in? Have you not seen the notice? This is private property.' We apologised politely, and said we had not seen the notice, nor did we realise that it was private property, but we had painted here for many years. Another problem for the plein-air painter. Sheepishly, she left us in peace.

John Worsdale was painting at Faversham. It was a cool summer day, and consequently he was dressed in a brown peaked cap, duffle coat, beard, looking generally like a Russian anarchist. Two young girls about 11 years old bombarded him with question after question. As he was trying to work, he did not reply. Eventually he decided that he was finished painting and made some sort of a reply to one further question – at which one child said to the other, 'I told you he was English.'

TOULOUSE WORSDALE
STOKING THE BOILER FAVERSHAM 9/6

25

One further difficulty encountered by the plein-air painter is what to paint. If painting in central London, there are so many subjects. Often the best place is actually in the middle of the road on a traffic island, or perhaps in the middle of Waterloo Bridge, or Lambeth Bridge. It can be done, there are small recesses along the footpath of the bridge which may have been used in older times for a particular purpose, where one can just fit in with painting gear, but it is a tight fit. The public are rushing past at a hectic pace so do not even notice you; but the painter has to really concentrate, the noise is terrible and so are the fumes from vehicle exhausts. Every so often the traffic comes to a standstill, and some bright spark makes a remark. 'What are you painting, mate, the bridge?' Undeterred, you continue. Under your breath, a choice expletive.

Central London has so many subjects. The skyline has changed on a yearly basis, as has the character of the riverbanks. But the addition of the Thames Walkway has maintained and even improved the access to the riverfront. There are many ways down to the foreshore at low tide, and the clever Wapper learns these quiet little secret passages. Here one can paint in peace, but the thunder of traffic can still be heard above the odd squawk of a seagull, or the rush of water that comes in after a passing launch. This can lead to trouble, as some of the craft produce a very big wave, and if you are too close to the water, disaster can strike. Alan Runagall had such an experience when painting on the foreshore at Rotherhithe. He was painting right down at the water's edge when a tug steamed past at high speed. He was nearly taken away by the wash, but his

A SORRY TALE

AS RELATED TO DAVID GRIFFIN BY THE LATE HARRY REDELL WGA. HARRY SCRIMPED AND SAVED IN 1938 TO BUY A MAGNIFICENT SABLE BRUSH WHICH COST HIM HALF A WEEKS WAGES. IT WAS HIS PRIDE AND JOY AND HE TOOK GREAT LOVING CARE OF HIS PURCHASE FOR MANY YEARS UNTIL THE FATEFUL DAY DURING THE SIXTIES, ON A PAINTING TRIP, A SCRUFFY DOG STOLE IT. HARRY WITH DESPERATE ENERGY SET OFF IN HOT PURSUIT ALL OVER THE FORESHORE. AFTER A LONG CHASE, SWEATING AND SWEARING HE RECOVERED HIS TREASURE ONLY TO FIND WITH DISMAY THE SIGHT OF AN UNRECOGNIZABLE CHEWED UP STICK WITH A FEW TATTY SABLE HAIRS HANGING OUT OF THE END. QUITE USELESS AND WORTHLESS.

brushes sailed off down river, like fishing floats bobbing on the waves. He said he had expected the brushes to float flat, but the metal ferrule weighed the end down so they floated upright.

Bert Wright on the other hand was painting on the mud opposite the 'London Apprentice' pub as the tide was rising. He had painted there many times before and was confident that he would finish the painting before the rising tide got him. He was concentrating on trying to capture the light on the mud, when his attention was drawn by shouting from the bank. Looking up, he realised that he was surrounded by the rapidly rising tide. His priority was to finish that part of the picture, so to the great amusement of the people watching on the bank he eventually waded back through deep water with his easel held high over his head.

The same painter had a similar experience at Eel Pie Island. Again an area that he knew well – in fact he was confident that the patch of ground that he was on would not flood. His determination was much the same as before, and once again he was caught out by the water, to the amusement of a number of geese who swam round him, no doubt thinking, 'Who is this idiot?'

It can be seen that it is not that easy to paint outdoors with these sorts of problems. There has to be a right

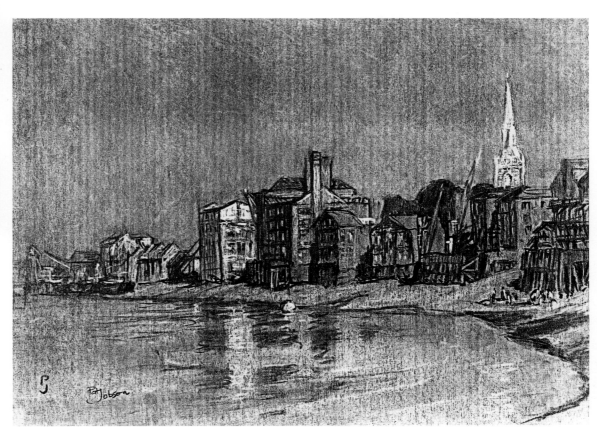

◄◄ ▲
Working sketches by Pat Jobson

attitude. One Wapper mentioned that he was not comfortable in a studio, too claustrophobic for him; others have mentioned the same, adding that outdoors you see so much better, life is living, the colours are real, exciting, vivid, subtle. Each moment is ever-changing, and it is often this changing moment that invigorates the painter, turns him on, and the result is always more exciting. When the sun goes behind a cloud, the whole picture is broken up into light and shadow. This can be caught by using a sketchbook and rapidly scribbling down the light and shade, or making a quick tonal sketch, not trying to define in detail but to capture the essence of the scene, that moment in time. Some painters produce a number of these sketches while walking round looking for subject matter, or even paint small 7"× 5" watercolour sketches, again without detail. The collection of sketches can be the basis for producing a painting in the studio on a future occasion. This method does allow you to collect a vast amount of information in a short space of time, and can be very useful if the weather is unpredictable.

Sometimes if the day is very cold, as it can be in April or September, a painting can be produced in the car. First of all the car has to be positioned in the right direction, and then where to sit? Each has his own way of

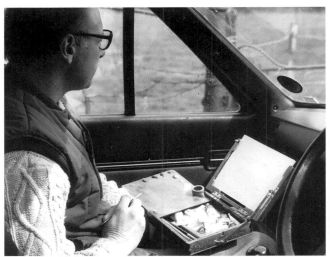

▲ Leonard Bennetts, all-weather painter.

Geoff Hunt and transport. ▶

Robin Mackervoy working in oils. ▼

John Powley using a box easel. ▼

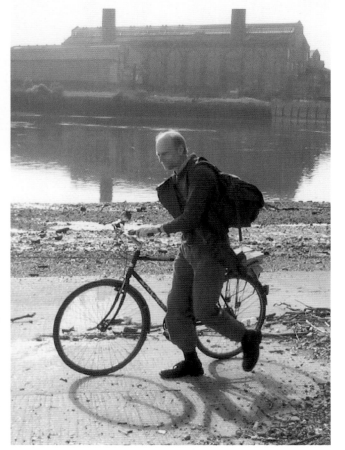

overcoming the inconvenience of the steering wheel. It is best to sit in the passenger seat with the seat pushed as far back as possible, giving clearance for the paintbox, water, and brushes. If one is using oils it is best to cover the seat and the floor well with old newspaper in case of spillage – it can happen. Of course you do have the advantage of your car heater which can create a nice warm atmosphere. The boot in a hatchback can be very useful, with the boot lid providing protection from the rain, and the inside floor of the boot as a seat. You can also stand and paint, using the floor of the boot to support your board and painting equipment. The car can also be used as a means to dry a painting with the heater, at the same time warming cold hands. Of course your car is also your base for having a sandwich or cup of tea, coffee, or hot soup, for renewing your painting water, warming up, changing from oils to watercolour, and even having a chat with your near neighbour, an exchange of ideas. So it is advantageous to have your car pretty close to the area you are painting, but this is not always possible.

A car is a very handy thing to have, but mostly the Wappers do their work out in the open, and sooner or later their painting gear must be transported the hard way, on foot – though a cycle may also be a useful option. Through personal experience everyone has evolved their own painting kit and their own way of packing and carrying it, all governed by their working methods. Some stand to paint, some sit on folding stools or chairs, some sit on the ground. Some work on an easel, some use a 'pochade box ' when painting oils, which can be supported on the knees when sitting down, or rested on a convenient post or even the top of a dustbin, whatever is nearby and handy. The main thing is to be comfortable and to have all the necessary equipment to hand. Each painter has his own method, just as each painter has his own style. The character is always recognisable from their stance – close

to the work, perhaps, or standing back, or bending over the picture.

It is cooler by the river than inland, so the right sort of clothing is essential. It is preferable to have several layers, which can be gradually removed or replaced as conditions change; and a hat to keep the head warm, or the sun off, or the wind at bay. Warm waterproof shoes and fingerless gloves are often welcome. Some painters carry an umbrella. A small one is not too cumbersome, and can be put up quickly to cover a watercolour painting before the raindrops ruin it. In time, the plein-air painter becomes an expert in organising the right equipment for each day's

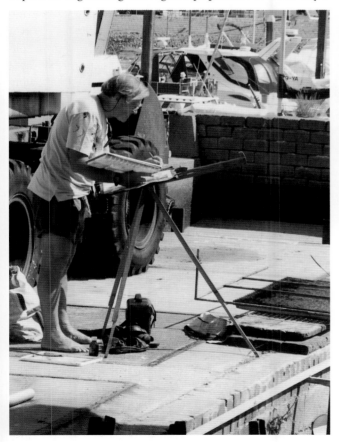

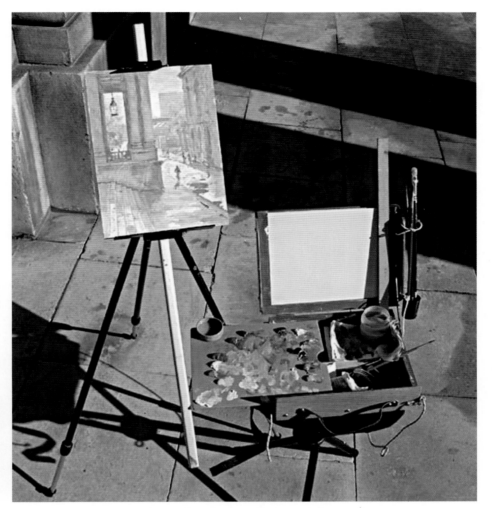

Between thunder showers at Greenwich. The painting box in view is the very compact all-in-one 'pochade box' (see the blank painting panel in the lid), though here it is being used just for paint mixing, with a lightweight easel carrying the work itself.

painting to suit the way he works. There really is no right and wrong, but more a question of common sense and what suits the individual. The worst thing is to give up painting for the day simply because of physical discomfort, usually through being too cold, but sometimes too hot. So forward thinking is important, as well as a positive attitude. It is better to be prepared for the unexpected than miss out on a good subject and a good day's painting.

The experienced plein-air painter will carry the equipment and clothing that he needs, but there are limits. It is very easy to fall into the habit of carrying

Paul Banning demonstrates the use of a more substantial wooden easel, angled horizontally for watercolour work.

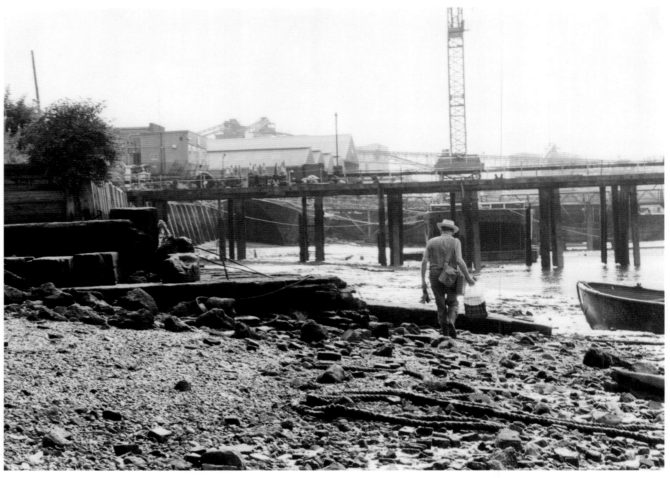

▶ The day's painting is in the bag, if you have been lucky. Trevor Chamberlain heads for the pub.

John Bryce painting at Battersea. Oil sketch by Geoff Hunt.
▼

everything every time, but that can make a heavy load to carry about all day, and discourages walking in search of subjects. Sometimes it is better to concentrate on one medium for each separate day's painting. At any rate the one essential piece of kit is a stout carrying bag or rucksack, comfortable to carry, preferably with shoulder straps so that your hands and arms are free for negotiating steps and gates, and to keep your balance on the muddy foreshore.

Despite all the problems, there is no substitute for the days when all goes well. You have the satisfaction of producing a work of art entirely in the open air, often against the odds; seeing life as it is, enjoying the sparkle on the water, the pool of light that makes the painting, the fresh air, and the companionship of friends who have the same interest. All this contributes to a good day's painting. The result may not always be perfect, but more often than not, you can say that you had a good time, and met the challenge of the day – and there will be stories to tell in the pub.

III
Today's members in their own words

Paul Banning

Fred Beckett

David Brunwin

John Bryce

Sidney Cardew

Trevor Chamberlain

Grenville Cottingham

Bill Davies

Roger Dellar

Anthony Flemming

Roy Hammond

Dennis Hanceri

Geoff Hunt

Pat Jobson

Robin Mackervoy

Ronald Maddox

Edman O'Aivazian

Denis Pannett

David Penny

John Powley

Michael Richardson

Alan Runagall

John Worsdale

Bert Wright

Paul Banning

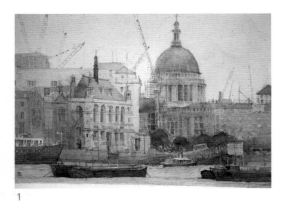

1

Joining the Wapping Group of Artists has provided me with the opportunity not just to meet regularly with a group of artists to paint, but with a constant challenge that I relish, and that is to paint *en plein air*. When I'm standing there in the mud, with the tide coming in or going out, and the light constantly changing, I can put up with the hot sun or the rain, because I'm working to capture the reality of the river at that moment. For me the challenge is to paint whatever exists today, and to know that I'm recording the changing nature of the river and the way in which people use it. I have to paint it warts and all, and not how it used to be with a veneer of nostalgia.

I find my subject matter instinctively and believe that time spent walking around and looking is invaluable, as

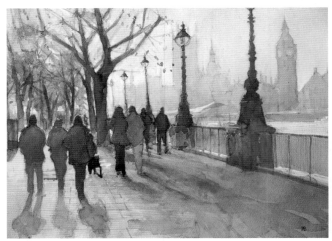

2

suddenly I'll see something that grabs me, and I go with that instinct. There's no point setting up to paint if I don't feel any emotion, and I only paint what inspires me. The Thames poses so many challenges and as I choose my subject matter I am conscious of what will work in the morning, or the way the light will fall in the late afternoon or early evening, and of how to capture the whole atmosphere before me.

There is a popular misconception that watercolour painting is a gentle hobby for the elderly. Wapping Group members soon learn to know better! It is demanding and requires a great deal of concentration and often mental and physical prowess. Everything moves on the river, people interrupt you, and then there's the British weather! So I may only have two hours to paint, and whatever happens, however much the light changes, or a storm builds up, I endeavour to capture the subject that charmed me to start with. But a painting is not a photograph, it is an expression, an interpretation, and within that there is always artistic licence as long as it is not overdone.

Some wonderful interest can be captured by using coloured paper. After all, many of Turner's great paintings were captured on Turner grey and blue watercolour paper.

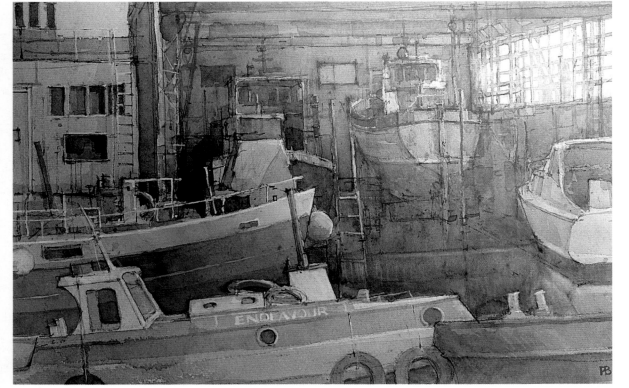

3

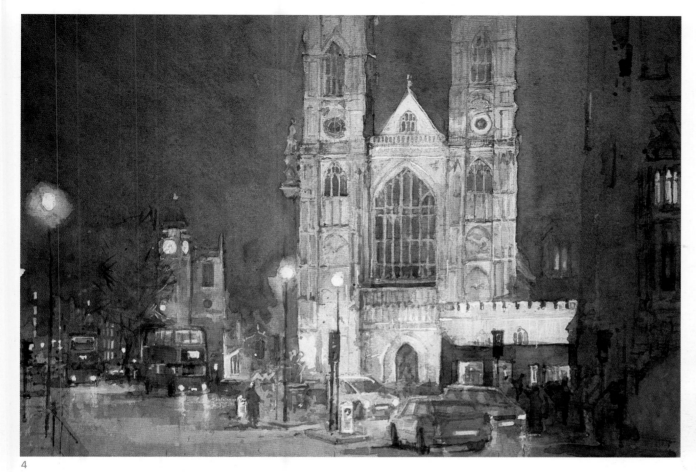

4

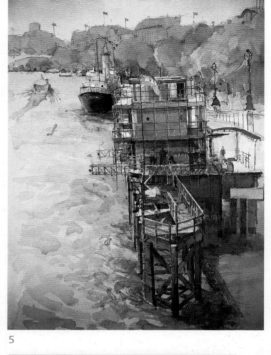

5

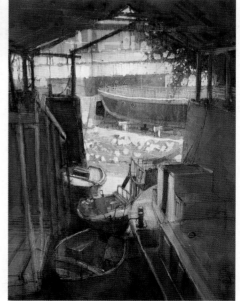

6

My favourites are grey, blue, brown, green, and buff 400 gm paper handmade by Two Rivers.

For me, the understanding of colours and mixing is a very strategic part of producing a picture that has depth as well as subtlety of colour. I tend to limit my palette to about six main colours, using large pools of colour, and paint very wet, often building up many layers of paint. This process requires infinite patience waiting for each layer to dry before adding the next.

Old brushes with no points to them suit me. It is the brain that paints, not the brush, and so we have to learn to paint what is difficult without the aid of special brushes and gimmickry.

I always stand to paint and my rule is to walk away and look at the painting from about ten yards away, to see the faults and what is working well. It's a fine judgement as to when a painting is finished, but I tend to give myself some space and distance from the painting for a few days and I find that usually gives me the answer.

1. St Paul's on a rainy day. Watercolour 10"x 15"
2. Winter light, South Bank. Watercolour 14"x 19"
3. Repairs, Eel Pie Island. Watercolour and ink 14"x 17"
4. Westminster Abbey at night. Watercolour 10"x 15"
5. Construction work on the Thames. Watercolour 19"x 15"
6. The old boathouse, Brentford. Watercolour and ink 23"x 18"

Fred Beckett

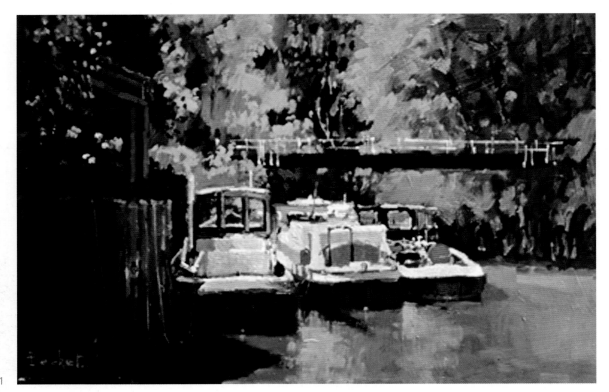

well travelled and at ease painting in oils or watercolour, whatever the subject matter. Being an East Anglian he has a natural love of landscape and big skies, but is constantly exploiting his ability, and in recent years has successfully introduced figurative aspects into his work. Fred is a fellow of the Royal Institute of Oil Painters and was its President 1995 – 1997. He is also an Honorary Artist Member of the Royal Institute of Painters in Watercolour and the Royal Society of British Artists. In 1998 he was elected to the Wapping Group, and this brought a new and pleasing dimension to his subject matter. Whilst being conversant with the marine and coastal aspect of the east coast, painting the Thames and its reaches provided a new and exciting challenge. In the few years he has been a member he has extended his knowledge, and his appreciation of history, from visiting many painting venues along the

Since retiring from business in the early 1990s, Fred Beckett has concentrated on developing his passion for painting. It was always part of the 'grand plan' to develop his artistic talent but he did not foresee that his progress would be so rapid in just a few years, leading to a growing demand for his work. His work is regularly exhibited at the Mall Galleries, and has featured in several solo exhibitions in prestigious galleries in London and the provinces.

Influenced by impressionist techniques, he is settled with his loose style, which brings freshness to his paintings. He is

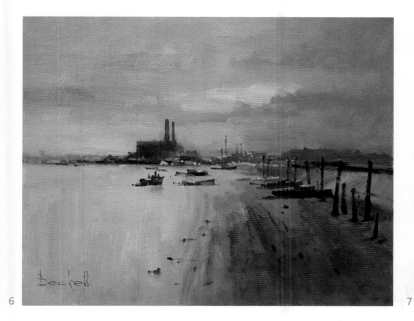

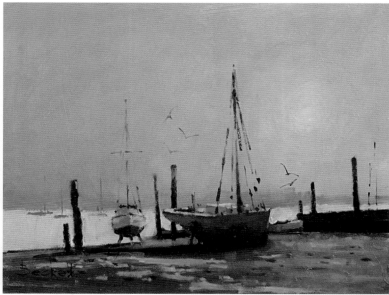

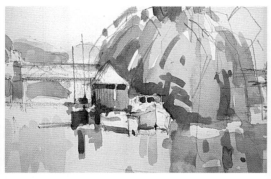

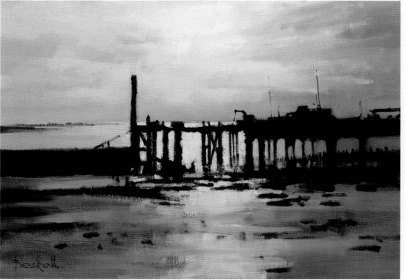

Thames, all in the great atmosphere and camaraderie that are special qualities of the Wapping Group.

With regard to technique, he is versatile in a range of media, often using watercolour or acrylics for small paintings, particularly on location. But it is the richness of oils that attracts him most, and this is the medium he uses for most of his paintings, whether outside or in the studio. The images shown here are typical of his paintings and pencil studies within the Wapping Group.

For painting supports, he uses ready-stretched Belgian linen canvas or board, each being well primed with acrylic gesso. In all media he uses artists' quality colour which ensures the richness, particularly in oils. Fred feels it very rewarding to finish a painting and find that it works in the way that he wanted. But however experienced you are, it has to be expected that not every painting will be successful and, in a sense, that is what motivates artists: painting is always a challenge. It is a new adventure every time you start!

David Brunwin

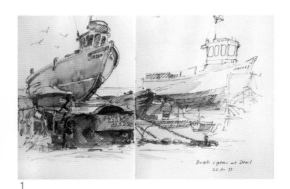

1

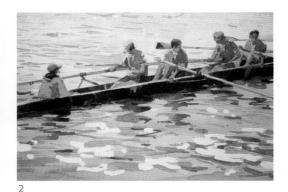

2

It's funny how things work out. I see from my earliest sketchbook that I was drawing Thames barges and French fishing boats when I was an eleven-year-old in Ramsgate. Fifty years later, I joined the Wapping Group of Artists! In between, I went to Oxford University and followed a career in science.

I did make some income as an impoverished student, illuminating oars for members of our first eight, when they had a successful year. Otherwise my painting was restricted to holidays and the occasional weekend.

My sketchbooks are an important source of inspiration and information to me. I usually try to capture the tonal values by adding some limited colour wash (it's quicker than shading). A similar effect can be achieved by using one of those cheap pens which have water-soluble ink.

I think that light and atmosphere are the most important elements to try and capture in a painting. It was a bright and breezy day at West Mersea when I painted the Essex smack beached for maintenance. The view is *contre jour*, which enhances the feeling of strong light. All the elements of the composition were there, just waiting for me to paint them, although the children didn't stay put for long!

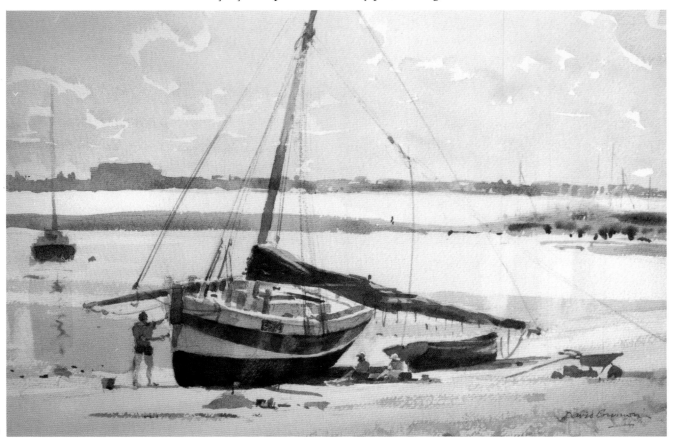

3

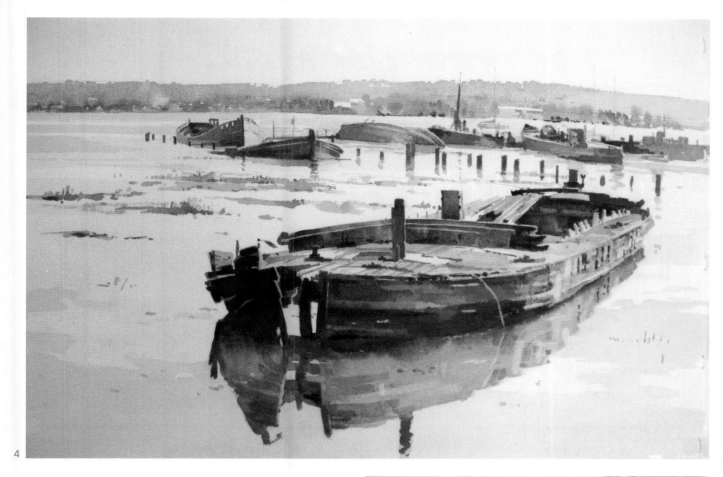

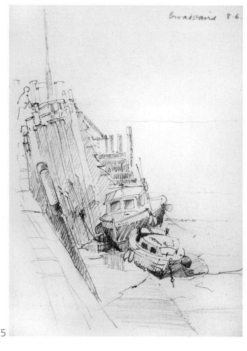

The atmosphere at Hoo was quite different – hot and still. It was very peaceful, almost dream-like, as the tide slowly crept in around these old hulks. This is a larger painting, which I finished in the studio. It was important to keep the washes big and wet, in order to convey the calm atmosphere.

The majority of my work is in watercolour, but I also like painting in oils. I use a pochade box and follow Trevor Chamberlain's advice to work on a small scale outdoors. Whatever the medium, and (almost) whatever the weather, there is nothing quite so pleasant as meeting up and painting with one's friends. It's a privilege and a pleasure to be a member of the Wapping Group.

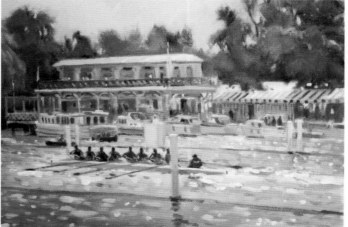

1. Sketchbook notes. Pen and wash
2. Going out on the tideway. Watercolour
3. On the beach, West Mersea. Watercolour 10"x 14"
4. Tide creeping in at Hoo. Watercolour 14"x 21"
5. Broadstairs harbour. Pencil sketch
6. Henley Regatta. Oil on canvas 10"x 14"

John Bryce

The dilemma: science or art? Well, science won at first. After graduation at King's College London, I worked as a research scientist at the Royal Aircraft Establishment, Farnborough. However, art was never far away and I painted whenever possible. I sketched the aeroplanes parked on the runway and the aeroengines which I helped to develop. Many of these aircraft paintings were exhibited at the Guild of Aviation Artists and I became a full member of the Guild in 1990. Retirement allowed me to develop my love of painting outdoors in watercolour. I also renewed my interest in printmaking and was elected a member of the Society of Wood Engravers in 2001.

Painting days along the River Thames with the Wapping Group provide a rich source of subjects and the companionship of painting as a group. A great admirer of the Impressionists, I try to capture the changing mood of the river, in watercolour and oil paint.

On one of the Group's painting days at the Freebody boatyard near Henley, a beautiful Victorian steam launch was being restored. The interplay of light and shapes made a strong image, inspiring first a watercolour then a wood engraving (which won a prize at the Originals print exhibition).

In central London, I particularly like the view of Tower Bridge from Rotherhithe, with St Paul's in the background. I was lucky when painting it because the bridge bascules were raised to allow a fine Thames barge to pass through.

Towards the mouth, the river merges with sea and sky. The Queen Elizabeth bridge, a wonderful sunset and a container ship passing through the narrows made a sublime subject, not to be missed!

On long runs into Kent or the estuaries of Essex, I often stay overnight in my old camper van, so as to start early next day, much to the amusement of my fellow

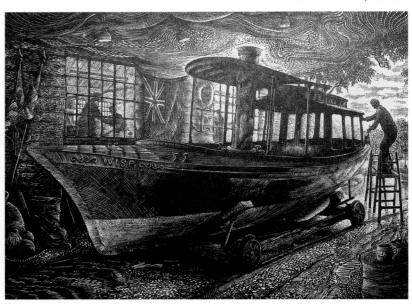

1

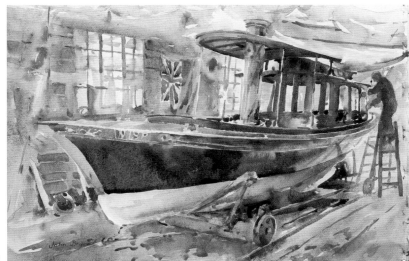

2

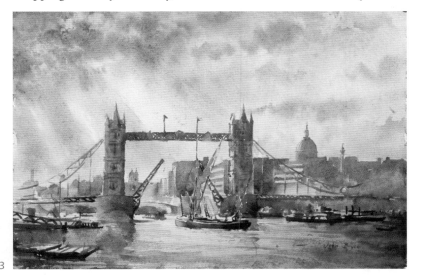

3

members. The effort is well worth while to catch the early morning light. Gillingham Pier, for example, appealed to me because of the gaggle of boats nestling under the harbour wall and light shining through the structure of the pier.

On another occasion, a long haul up to Wivenhoe, near Colchester, was rewarded by a fine view across the creek to the church, pub and boats on the mud.

I exhibit regularly with the RI, RSMA, GAvA and contemporary print shows in London and locally in Surrey. Now I have the privilege of exhibiting with the Wapping Group. As the only printmaker in the Group, I feel I can make a unique contribution, and I look forward to promoting my art with this fine fellowship of artists.

4

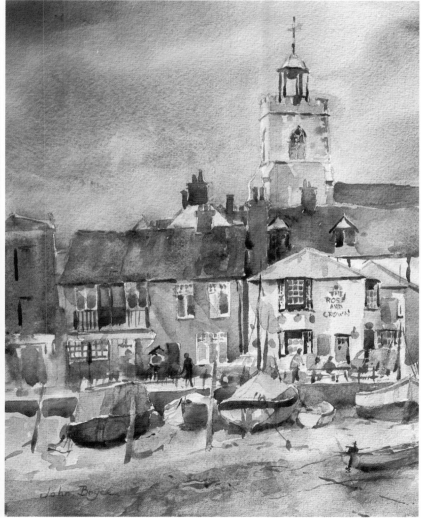

5

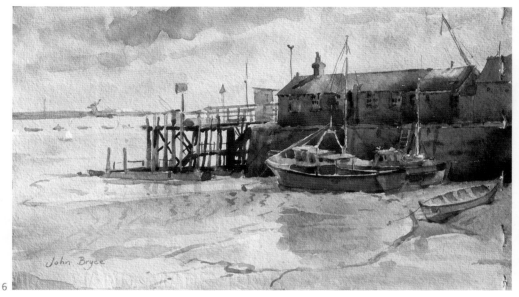

6

1. Varnishing the *Wisp*. Wood engraving 6"x 8"
2. Varnishing the *Wisp*. Watercolour 15"x 22"
3. Tower Bridge. Watercolour 10"x 15"
4. Dartford Crossing. Watercolour 9"x 14"
5. Wivenhoe. Watercolour 13"x 11"
6. Gillingham Pier. Watercolour 9"x 15"

Sidney Cardew

I was born in the East End of London near the 'Prospect of Whitby', the pub where artists met and formed the Wapping Group. I later moved to Essex, where after the war I was educated at the South East Essex Technical College. Doing well at technical drawing, I started work in engineering before being called up for my National Service in the RAF.

I then worked for Ford Motor Company as a draughtsman before becoming a senior design engineer. I had to retire in 1986.

I had started painting in 1970 when my sporting activities ceased. A self-taught artist, I did have an initial tutor, Tom White, who taught me to 'see' and to realise the importance of tonal values. I paint in both oils and watercolours but prefer the spontaneity and transparency of watercolours –

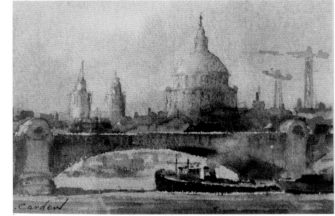

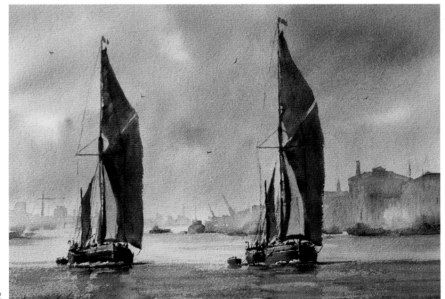

the wonderful fusion that can be created in the painting of a sky.

I greatly admired the work of Edward Seago, John Singer Sargent, Jack Merriott, Trevor Chamberlain and David Curtis; all have a distinctive style of their own. Living in Essex, I found a fascination for marine subjects on the backwaters and costal inlets, especially the stature and elegance of the Thames barges in full sail, or sitting on the hard.

My introduction to the Wapping Group in 1983 was by the late Peter Gilman, who invited me to be his guest on Wednesday painting evenings. I was made to feel most welcome among this very dedicated and likable group of artists. This I considered a turning point in my career, as it was a great honour to paint in the company of so many great artists. Unfortunately in 1986 my life turned upside down when my 23-year-old son Steven had a car accident and suffered a severe head injury that was to mean me retiring from Ford, and stopping my painting activities. He needed full-time care and help, so we worked hard to get him to be independent with some aim in life.

After two years, my friends from the Wapping Group made me realise that I should start painting again, and it was a great incentive for me when I finally became a

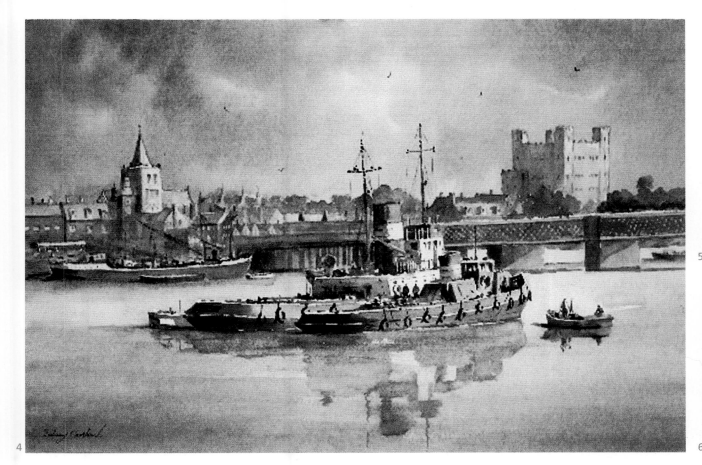

member in 1989. Since joining, my work has improved considerably, as I found working *in situ* was a totally new experience and painting a variety of subjects and weather conditions made me realise the importance of painting from life to capture a true feeling for the subject.

Steve, my son, also improved and he decided he wanted to paint, so I gave him all the help I could and he now does sculpture, pottery and paintings. He has had successful exhibitions of his work and has had paintings in the RSMA exhibition at the Mall.

I also take him painting with me when I can to the Wapping Group meetings, where he is made to feel most welcome by all. I think his ambition is to one day join the Group.

I fulfilled one of my ambitions when I was made a member of the RSMA in 1998 after great perseverance. I exhibit regularly in the Mall Gallery and my work can be found in various other galleries, both home and abroad, as well as in London offices and personal collections.

I am always willing to undertake commissions, and find it very stimulating to travel abroad to paint in Venice, France, Egypt, Morocco, Tunisia and Istanbul.

I do, however, think that there is nothing more satisfying than finding well-worn boats moored by a jetty at low tide and painting a picture that I hope the viewer will get as much pleasure from as I did in the painting of it, and then retiring for a well-earned drink with the Wappers.

1. Thameside tug. Watercolour 11"x 15"
2. Thames barges under full sail. Watercolour 11"x 15"
3. View of St Paul's. Watercolour 5"x 7"
4. Tugs at Rochester. Watercolour 15"x 22"
5. Relics on the Medway. Watercolour 15"x 22"
6. Red boat on the backwaters. Watercolour 7"x 11"

Trevor Chamberlain

Born in Hertford in 1933, he is a marine, town, figure and landscape painter in oils and watercolours, with particular emphasis on atmosphere and light, painted *en plein air* in all weathers.

Started painting seriously at the age of 12 with encouragement from his secondary school art teacher, C. R. Trevena, with additional informal tuition and guidance from Alfred Wright, tutor at the Ware Evening Institute. His interest in architecture was stimulated by Sir Edwin Lutyens' nephew Eadred Lutyens, whose tuition group he joined. In 1950, after leaving school, he started working locally for N. F. Cachemaille-Day, an ecclesiastical architect. From 1953 to 1955 he served a term of National Service in the Royal Engineers, afterwards taking up painting professionally in 1964.

Elected a member of the Chelsea Art Society in the same year, he served as its President for a period in the early 1980s. His oil painting 'Derelict Flour Mill, Walkern' was acquired in 1968 for the Government Art Collection. Elected a member of the Wapping Group in 1969, and a member of the Royal Society of Marine Artists in 1970. Oil painting 'Swilling Down, Billingsgate Market' was acquired in 1971 by the Guildhall Art Gallery. Represented by works in the 'Critic's Choice' Exhibition in 1972 at Tooth's and elected a member of the Royal Institute of Oil Painters in the same year. His oil painting 'Market Day, Hertford' was acquired by Hertford Museum. The book *Oil Painting Pure and Simple* was published in 1986, his book *Oils* was published in 1993, followed in 1999 by his book *A Personal View – Light and Atmosphere in Watercolour*.

Featured on Connecticut TV, BBC TV, and the film *The Colourmen* produced by Windsor and Newton. Watercolour 'Parliament Square, Hertford' was acquired by Hertford Town Council. Eight paintings have been exhibited over the years at the RA Summer Exhibition. He continues to exhibit widely in London, the provinces and abroad, winning numerous prizes and awards. His work is represented in many corporate and private collections.

1

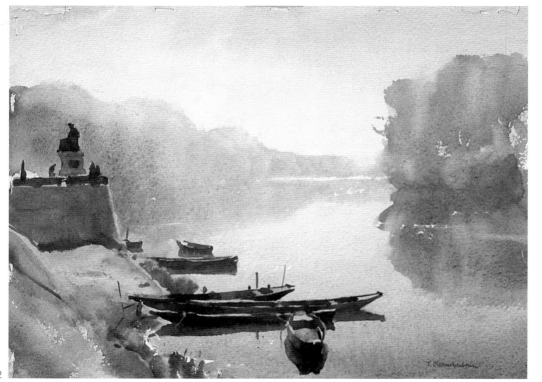

2

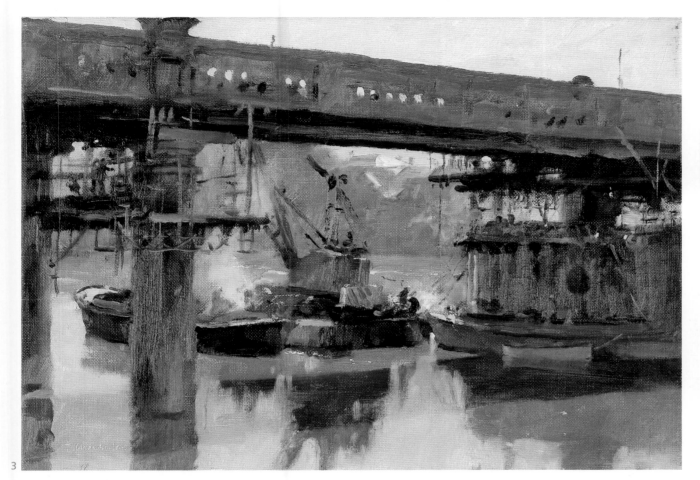

3

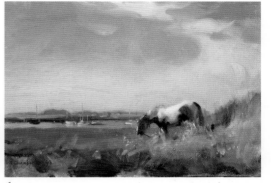

4

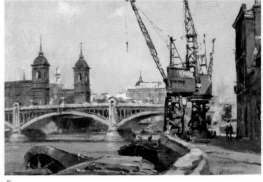

5

The changing river

When I became a member of the Wapping Group in 1969, commercial activity and traffic on the river was still strongly featured. Although only a shadow of its former self in the 1930s and '40s, sailing barges, lighters, tugboats and large cargo ships were still in abundance when I joined. The Upper and Lower Pools were busy with working cranes, wharves, jetties and warehouses, and sea-going freighters manoeuvring, loading and unloading. I remember, for instance, that the Surrey Commercial Docks were especially active, where large vessels from Scandinavia and Russia would unload their cargoes of timber. Today it is a concrete jungle of modern glassy flats and housing, and the same can be said about most of the Thames reaches, although it is still possible to seek out little enclaves which recall something of the lost age of this once mighty river.

1. Threatening cloud, Rotherhithe.
 Watercolour 9½"x 7"
2. Moorings, Chinon, the Loire, France.
 Watercolour 10"x13½". Painted on one of the
 Wapping Group's painting trips abroad
3. Railway bridge maintenance, Putney.
 Oil 10"x 14"
4. Horse on Erith Marshes. Oil 7"x 10"
5. Bankside in 1970. Oil 14"x 20". Painted soon
 after joining the Wapping Group.

Grenville Cottingham

I was born in Devon, and as my father was a keen yachtsman I became interested in boats at an early age. After a formal art training, I took a year's post-diploma course at Liverpool University and experienced a large busy port for the first time.

Whilst there I undertook some commissions for the company Ocean T&T. Shortly after leaving Liverpool, I was engaged by the Marine Society as their first sea-going artist tutor. In this capacity I was able to travel all over the world on a variety of ships, which gave me a wonderful experience of working ports in all sorts of conditions. I also had the chance to undertake further commissions for various shipping companies as well as building up a large amount of reference work for my own use.

Since this I have undertaken many commissions for companies such as P&O, OCL and British India, as well as for RNR (London), the Royal Fusiliers and many commercial banks, building societies, investment and insurance companies – as well as many private commissions.

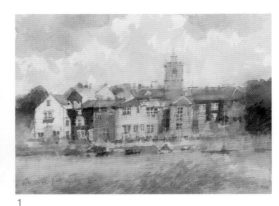

1

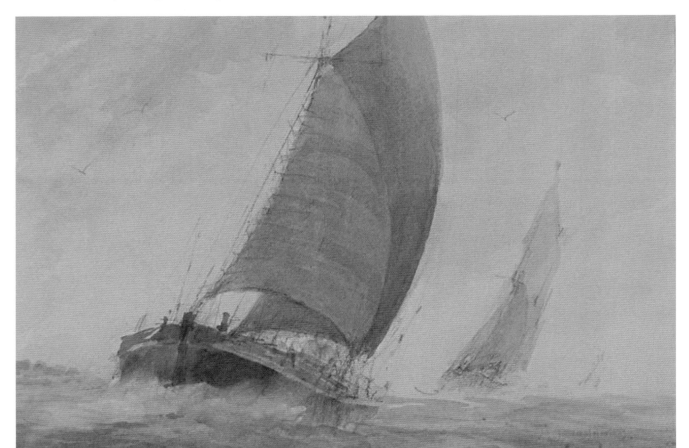

2

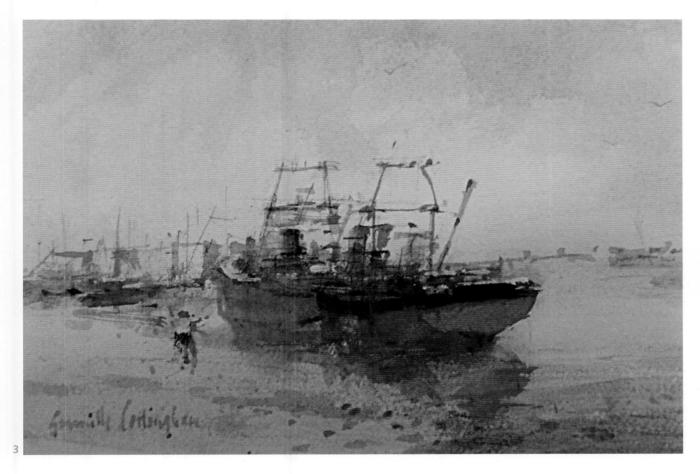

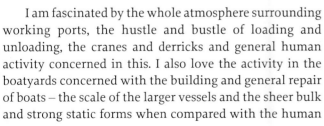

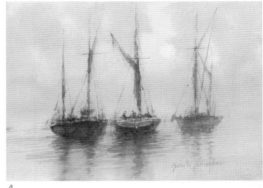

4

I am fascinated by the whole atmosphere surrounding working ports, the hustle and bustle of loading and unloading, the cranes and derricks and general human activity concerned in this. I also love the activity in the boatyards concerned with the building and general repair of boats – the scale of the larger vessels and the sheer bulk and strong static forms when compared with the human activity around them. I enjoy painting strong colours in small areas set against large areas of neutral tone.

As well as the large ports, I find small fishing ports very attractive as subject matter; again the human activity and the general clutter and smell, wonderful tonal and atmospheric conditions, depending on light and weather, which I try to capture.

Bill Davies

As I jam my easel into the mud again and scramble around for a stone big enough to help hold the easel up against the breeze, things are possibly not looking that promising.

To start with, I know from bitter experience that the boats which are all cheerfully well composed in front of me will be facing directly towards me within the hour, the clouds look like they have absolutely no intention of staying still and I can see an issue of trying to avoid the perennial challenge of nature's greens, that to the strolling visitor up on the towpath must look perfectly charming but have always sent me into a trembling sense of inadequacy.

I have also left my glasses in the car again.

There's always that sense of the possibility of making a fool of oneself in trying to paint out here, away from the privacy of a warm studio. But I have been trying now for 30 years with the Wapping Group, and that must be close on 500 goes. I suppose it has got easier. I can be civil to passers-by but still concentrate. I am much quicker now,

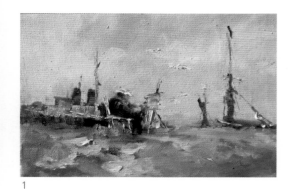

1

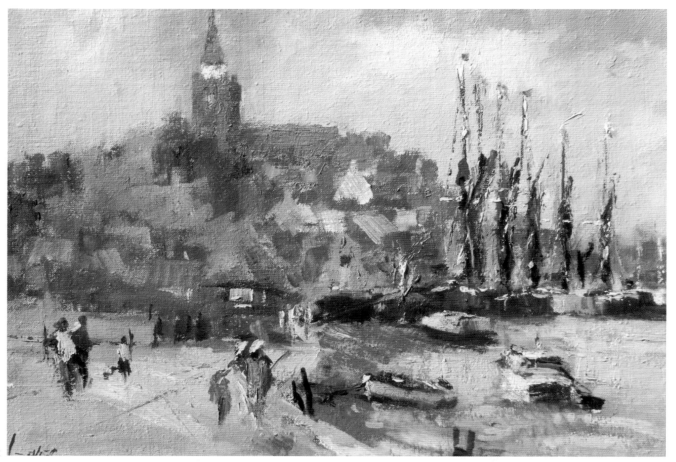

2

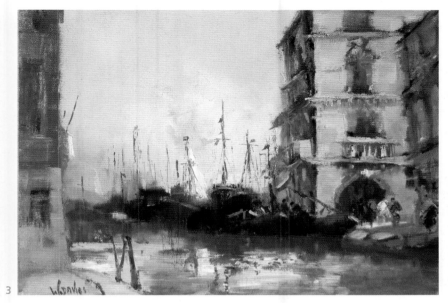

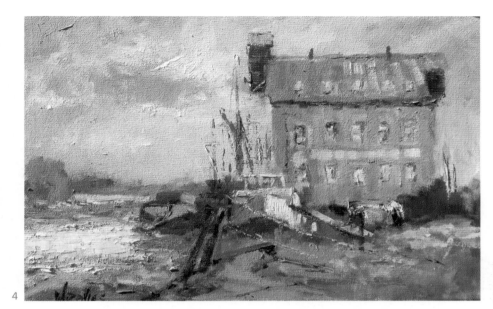

at least at painting, and I am less worried about what my son will say when I show him yet another painting of boats. Perhaps that's what the Wapping Group is all about: it preserves the individual challenge, it leaves us alone with the river, but gives us the encouragement and enjoyment of discussing the day's work in the evening. Fellow Wappers can't do the painting for me, but they certainly help me to turn up, and so to try again.

The Thames sometimes seems so small, and on other occasions so dauntingly massive and permanent. In 30 years both of us have been through a bit. She has lost a lot of her industry but gained some clean and fresh waterways. I have changed my hair colour and now limit myself to just two canvases on each visit. I like to think that the changes are out there in some of my better work, captured in some genuine way that only a painting done on the spot can truly represent.

I am fortunate to travel frequently, and like all painters my holidays are very much of the busman's variety. I could never get on a plane without a paintbox stowed safely in the hold – anyway I would be a nightmare to holiday with, deprived of what I love to do, my work! I have enjoyed countless visits to Venice and Provence, and my vocation has brought me some great adventures and true friends in Italy and France. People seem kind to painters somehow, as if it stirs some flicker of interest, a little challenge to see if they might find some genuine expression of themselves and the scene in front of them, one day. Of course painting abroad has its own challenges, but the constant practice of the Wapping season on the Thames gives me an enormous sense of hope, and at least a little confidence to stand out there in St Mark's Square, Venice, and to do what I love to do.

Back to the riverbank, and it's been great fun really, as I stand back and think about those finishing little 'five-bob touches' which I will take an age over back in the studio. Bring out that figure there, a little splash of cadmium, I am thinking. But for now it's back in the box, separated, by the same old matches, from the next effort to allow it to make the journey back home without smudging. The box is closed by the same old rubber band made out of a bit of inner tube. And yes, the boats turned out quite OK in their more or less random orientation, the towpath looks great with only the merest hint of a tree, which anyway isn't green but more a sort of bluish grey in today's light.

No-one will ever be the wiser, because I was the only one to see it all. Now where's that pub?

1. Wednesday. A working Wapper. Oil 12"x 16"

2. Barges at Maldon. Oil 14"x 20"

3. Chioggia (a busman's holiday). Oil 12"x 16"

4. Faversham Creek. Oil 14"x 20"

Roger Dellar

I consider myself equally as a studio and an *en plein air* painter. I enjoy the challenge of sifting through the information that I see in front of me, absorbing shapes, textures, colours and tones to pare them down to the essence of the subject. It is all too easy to suffer from information overload. When in front of the subject, there is always an urgency to capture it before the light and shade, or tide, or people and boats, go. I love this element of painting on the spot.

There is a point in the painting process when the painting starts to give me back that excitement that I had when I first wanted to paint it; I will stop at that point, leaving some painting to be considered and finished back at the studio with a fresh eye.

In the studio, I am not pressured to paint the subject as seen. I can move objects, change perspective, colour and lose edges to form a more essential and abstracted picture. I can work from sketches and paintings that have already been painted on the spot, or from photographs, or even just from memories that I have stored from these experiences.

My choice of subject is a personal one. I enthuse about colour combinations. I see the light hitting a surface going into shadow, tonal contrasts, an interesting series of shapes that make a composition. I am always looking for intimate strong shapes.

People feature in many of my pictures, as I am fascinated by their presence in the environment; they can put a meaning to a subject. Architectural structures, bridges, buildings, traffic lights, cars, road signs, even rubbish bins are all of interest to me, as they form shapes and contrasts, and they are all part of today's world.

I would have loved to have been a painter in the early days of the Wapping Group, as the atmosphere and activity of London and the Thames must have been intoxicating; but I would not paint these for nostalgia's sake, as this is not what I am experiencing now.

London is such a vital place, alive with everyone buzzing around with their own agenda; the activity is tremendous. I paint a large number of night scenes. Night time is when buildings are partly obscured by the dark, when lights and neon signs shine and reflect colour in some areas, and other areas are lost. This enthusiasm comes from my childhood memories of seeing London at night when going to the annual pantomime.

I am a painter whose values are always changing, with each new year reassessing my views. Who knows what my new stimulus will be next year?

1

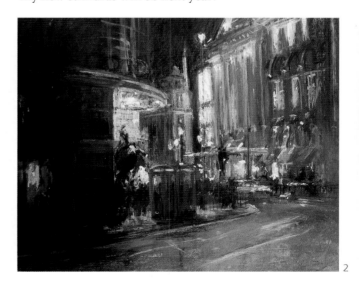

2

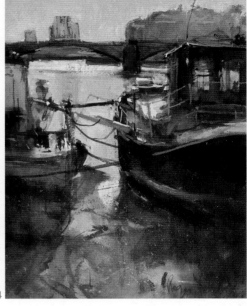

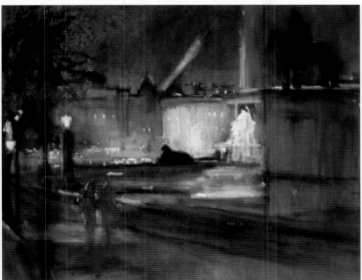

1. Southbank.
 Water media
 12"x 10"

2. Night lights,
 Haymarket. Pastel
 16"x 20"

3. Boatshed on the
 Thames. Pastel
 28"x 46"

4. Boat at Battersea.
 Water media
 12"x 10"

5. Trafalgar Square
 at night. Water
 media 16"x 20"

6. Towards St
 Martin. Oil
 20"x 30"

49

Anthony Flemming

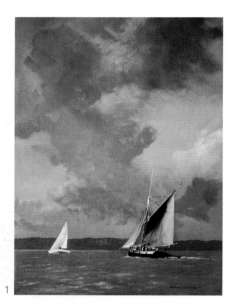

From an early age I have been associated with the Thames estuary. My earliest memories are of playing on the shingle beach near Whitstable. Here the tide receded for almost a mile across glorious mudflats. When the tide eventually came in the older boys launched small sailing dinghies and proceeded to race up and down along the shoreline. I knew, even then, this was for me; skimming over the waves using only the mysterious power of the wind. At the age of seven or eight I contrived, with the help of the local garage owner, to rig a tiny clinker dinghy. The mast was bamboo, the sails were of cotton, cut down from the big boys' cast-offs. After many a capsize into that peculiar muddy water I too became one of the boys, albeit a rather small one.

Since these early times I have sailed in a variety of craft from the humble to the grand luxury yachts in many parts of the world, including crossing the Atlantic some two and a half times. But the muddy grey-green Thames estuary always feels like home to me.

To crew on a Thames barge or a Whitstable oyster smack in a sailing match, or even just making passage, is my idea of heaven.

Drawing and painting also came to me early. To attempt to capture the moods of the sea and the sky became a challenge. Today, so many years later, the challenge is still there. Nothing afloat is ever still. To set up an easel on deck and expect to produce a finished canvas 'is just not on'.

Aboard I always have a sketchbook with me and often a small pochade paintbox containing a limited range of oil paints. To capture a sky, or given time on a long reach, the slant of that smack? These fragmented sketches, more than any photograph, can later in the studio so vividly bring back the whole scene.

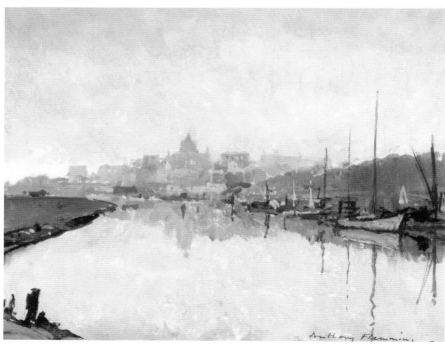

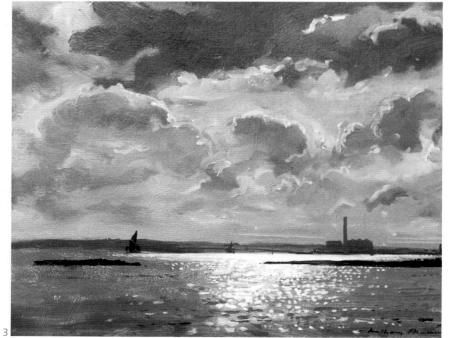

It was in 1989 that Donald Blake introduced me to the Wapping Group and after the obligatory probation year I became a proud member in 1990. As a member I have been introduced to many new painting venues. In particular many in the upper reaches of the rivers in the south-east of England. The companionship of fellow artists each with their own style is a revelation.

Eight or ten Wappers painting the same view will create eight or ten different and distinctive pictures. This variety serves so to enliven our annual exhibition. I look forward eagerly to the coming season, painting and drinking with my fellow Wappers.

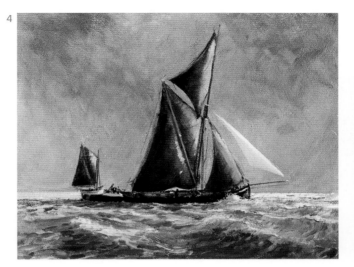

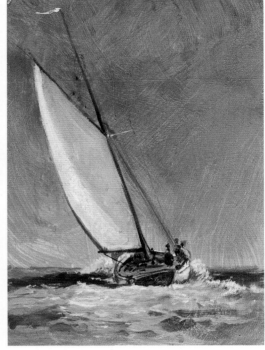

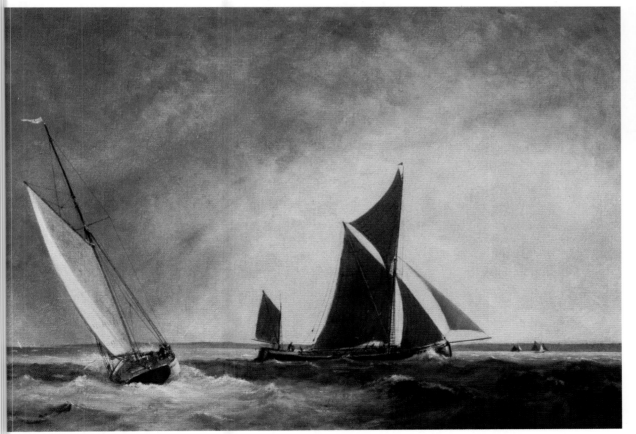

1. Ancient and modern. Oil 18"x 14"
2. Rye. Oil 8"x 10"
3. Cloud study. Oil 8"x 10"
4. Sketch of barge. Oil 5"x 7"
5. Sketch of smack. Oil 7"x 5"
6. Fresh breeze. Oil 24"x 36"

Roy Hammond

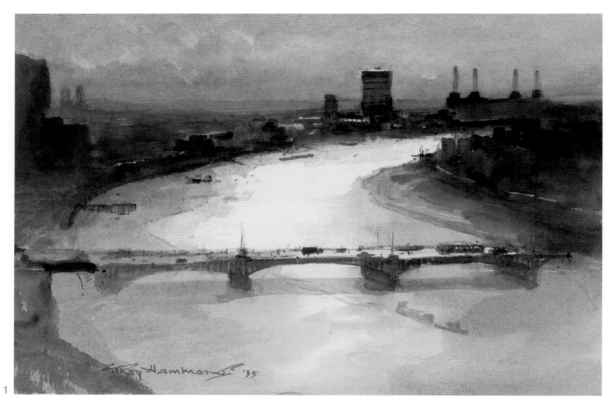

discovered that painting for me was an activity that was not relaxing, but exhilarating or depressing – depending on how the work in hand was evolving.

Even with the availability of a plethora of how-to-do-it books, the challenge that painting in watercolour presented was formidable. To try to improve my success rate I studied the work of the nineteenth-century British water-colourists at the Chris Beetles Gallery in St James's, and this has increasingly enabled me to develop techniques hitherto unknown to me.

Since I joined the Wapping Group of Artists in 1993, the camaraderie of the group on our Wednesday painting sessions along the river and the pint in the pub afterwards have made my return to the Thames a great pleasure.

I was born on Christmas Day 1934 just a stone's throw from the River Thames in London's East End, and the ever-moving tidal flow of water has always fascinated me. When WW11 hostilities began in 1939 my family moved away from the docks for safety reasons. We settled in my grandmother's home, but still felt the connection to the Thames because her house backed onto the tidal reach of the River Roding in Ilford.

In 1955, after serving in the RAF, I took employment with Ford Motor Company and trained as a design engineer.

I started painting in the early seventies as a diversion from the exactitudes required in a drawing office, and soon

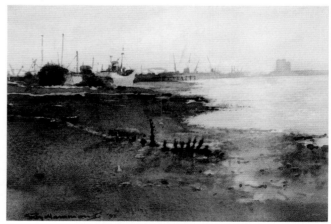

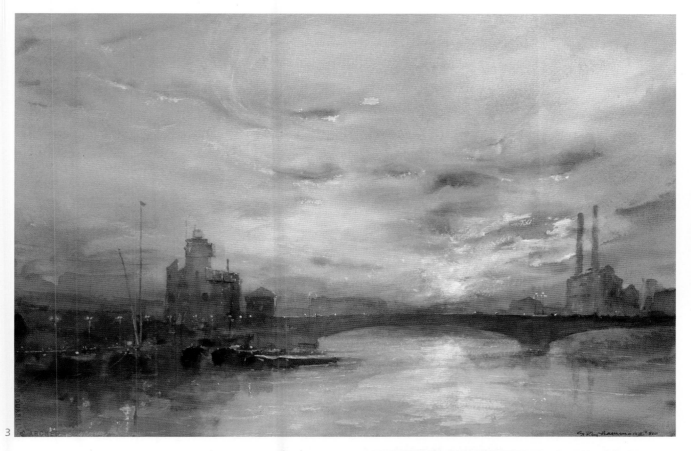

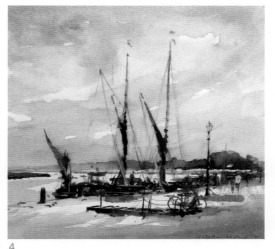

1. Moonlight, Battersea. Watercolour 7"x 10"
2. Low tide, Chatham. Watercolour 5"x 7½"
3. Chelsea Reach. Watercolour 14⅝"x 22"
4. The Hythe, Maldon. Watercolour 10"x 10"
5. Will it ever stop? Watercolour 6¾" x 8"
6. Mist on the river, Greenwich.
 Watercolour 6½"x 10"

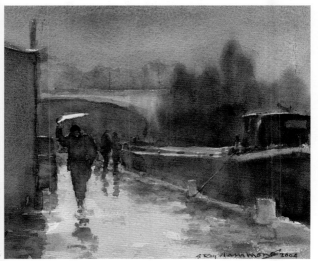

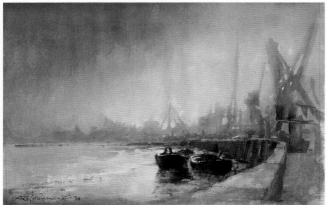

Dennis Hanceri

Dennis studied graphic design at St Martin's School of Art, and was employed by International Publishing Company for many years. He is a member of the Royal Society of Marine Artists. He has had several one-man shows in the USA, and has completed many commissions including those for the Phocean Ship Agency, Bracknell Corporation, and Ville de Paris. His work is represented in many public and private collections.

His main subjects are ships, sea and the sky. He has a great interest in colour and the gouache medium. He is very fond of the Dungeness/Rye area. which offers continuously changing moods and colour.

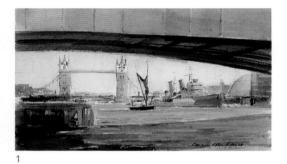

1

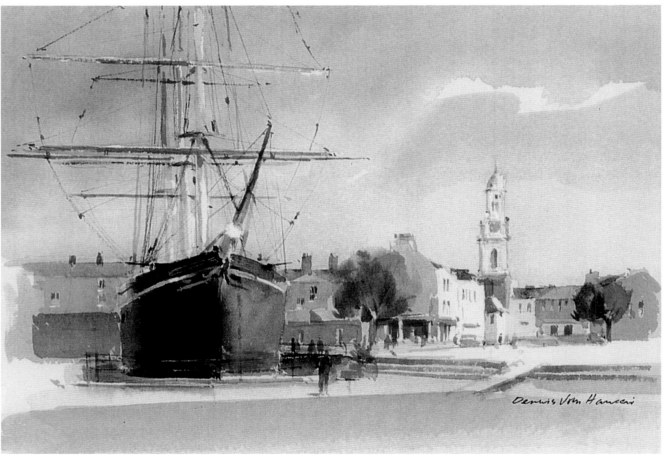

2

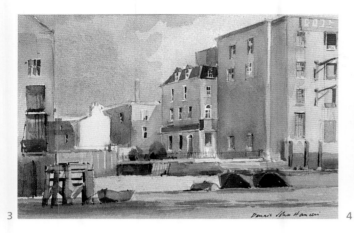

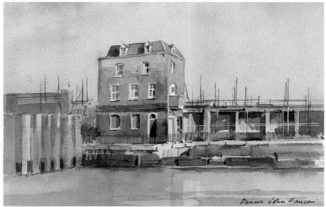

Searching for a subject

There is a moment of decision which has to be taken when contributing to a book on painting.

I shall not refer to technique or material needed, but to give my reason for the three paintings I have chosen for this page.

Simply, I was fascinated with the three-storey building, and knowing what inevitably might happen.

The change that has taken place along London's riverbank may excite some budding architects, but has deprived some of us of subjects that were once the mainstay of the Wapping Group.

However, with so much expertise among the members, that seems to offer not too many problems.

The subject I have illustrated I like to regard as a situation – the other situation being, will it be demolished like many other buildings of interest, or remain standing?

I hope the finished result answers that question.

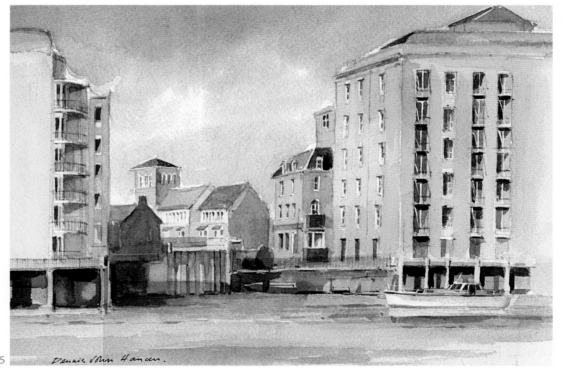

55

Geoff Hunt

Many of the Wappers do other kinds of art, and the other kind I do is studio-based: sizable paintings of square-rigged sailing ships that can take many weeks to complete. So I find a great joy in escaping from the studio to paint outdoors, where there is such a thing as weather, and where the action is a lot quicker. Though I still use oils, as I do in the studio, the paintings measure nine by twelve inches rather than twenty by thirty, and they take less than two hours to complete, not upwards of four weeks.

I like equipment to be as portable as possible – you should be able to walk at least a mile carrying everything you need – but in my case that doesn't mean light; it just means a very heavy-duty fisherman's rucksack, plus an easel and stool. I like to believe I can cycle with this kit, and sometimes do so, but only at the cost of a bit more simplification. I carry a pochade box but also a light easel, so that the 'big' picture of the day, if inspiration strikes,

1

2

56

can be an impressive nine inches by twelve or ten by fourteen, instead of the pochade's eight by ten.

I always try to finish these little studies on the spot, and very rarely add more than a few touches later, mainly to restore the inevitable damage when the wet painting is moved. The whole joy lies in the challenge of those two hours in the open air, responding to the subject rapidly (though actually choosing the subject may take some time). Something is lost if these images are reconsidered in the studio. But neither is the outdoor painting like a snapshot. Many changes occur during the session. The tide rises or falls, boats and figures come and go, clouds gather or disperse; and of course the light is always changing. All the time you are selecting from what appears, so that the finished piece records not so much an instantaneous scene, like a photograph, but something of the whole experience of that span of time. And when I see these little images again, they powerfully recall the

conditions they were painted in: Teddington Weir, for just one example, painted in fifty-five minutes on the spot. My knees couldn't have lasted any longer. I was standing up, wedged against the footbridge railing, with my paintbox and easel tied on top of the handrail to stop them pitching into the river, while mountain-bikers grazed past my back on the narrow footway. And then there came the cloudburst ...

5

1. Lock gate reflection, Battersea. Oil on panel 12"x 9"

2. Low tide, high summer, Isleworth 2003. Oil on panel 9"x 12"

3. Teddington weir from the footbridge. Oil on panel 8"x 10"

4. Green shutters, Strand on the Green, Oil on panel 9"x 12"

5. Tugboat at Greenwich. Sketchbook page

Pat Jobson

It was my good luck to join the WGA at its inception, being invited by Howard Penton when I was demobbed from the Royal Navy in 1945. He belonged to the Langham Sketching Club, whose membership formed the nucleus of the Wapping Group of Artists.

The Langham example came through to us. They met weekly through the winter. In the summer they branched out to enjoy sketching the Thames.

Prominent Wappers in the early days were Jack Merriott, our first President, the internationally esteemed marine painter Arthur Burgess, Eric Thorp, Wilfred Fryer and Willy Watkins.

In those days we faced a challenge to produce not only our best artwork, but to emphasise the character of the river subjects. The Thames provided not only shipping

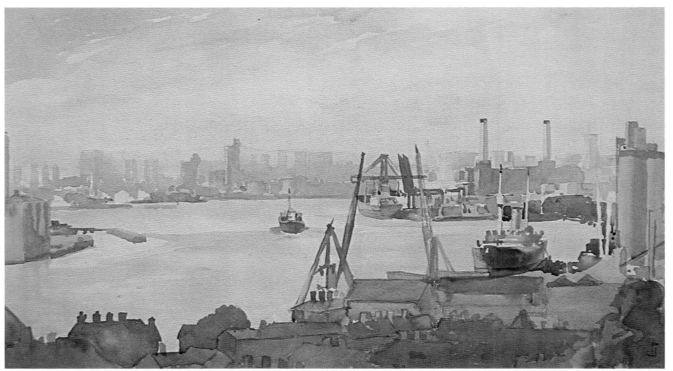

subjects together with all the small craft, but of course the fascinating backgrounds of old buildings, wharves, cranes and bridges. Draughtsmanship had to be accurate enough to satisfy not only seamen critics, but also the lovers of old architecture, all set in the changing atmosphere that would please the Thames lovers.

We mounted our first exhibition in the Port of London Authority's headquarters building by courtesy of the PLA chairman Sir John Anderson. This was opened by the well-known writer A. P. Herbert. It proved to be a great success, ensured by the support of the shipping and maritime insurance world, and was saluted by a feature article in *Picture Post*.

The Thames then was a very busy highway. Commercial ships lay at moorings in the stream surrounded by

1

2

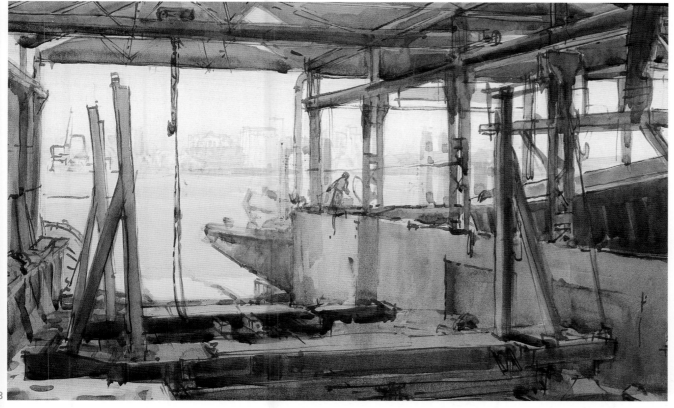

1. Teddington. Pastel 13"x 16"
2. Blackwall Reach. Watercolour 10"x 17"
3. Boatshed. Watercolour 11"x 17"
4. In the estuary. Pastel 14"x 16"

3

4

lighters and barges, or secured to wharves along either bank. As now, passenger ships lay in the docks, whilst sailing barges carried cargoes up into the Essex rivers or down the Kent coast. All wonderful to artists. Mist, smoke and steam added a subtle mystery facing us with endless pictorial effects, and all the time there was movement and life.

At the very start, Fred Winby designed our Tug and Palette motif which we still use today for our publicity. It was Fred who started the *Annals*, which included notes and sketches by members; this was continued by Pat Jobson and Charles Smith.

In 1950, war-damage repair to the PLA buildings forced us to find another venue for our annual exhibition. We were deeply grateful to the Gresham Committee for allowing us to show in the Royal Exchange – a favourite lunchtime gathering place for many City workers. Subsequently we were lucky to be invited to exhibit in St Botolph's Church, Aldgate where we showed for thirty years. Our recent venues have been the City Art Gallery and the Mall Galleries. Wappers are as enthusiastic as ever and confidently look forward to a centenary exhibition – with luck.

Robin Mackervoy

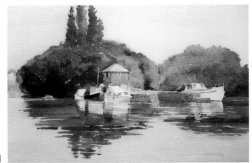

The Wapping Group was known to me for a number of years for its fine reputation, and I had found early members such as Jack Merriott and George Ayling inspirational. Later I met with and got to know others through painting holidays, local societies and the London Sketch Club. Invitations to paint with and become a candidate culminated in my election as a member – a red-letter day! I am currently the Social Secretary and arrange the season's starting and ending whitebait suppers and also the Annual Dinner.

Preparations for painting days include priming of panels and canvases, stretching watercolour papers and collecting together other equipment, including weatherproofs. The programme of venues is varied and arranged to be fair to those living either side of the capital. Although there is much less commercial traffic on the Thames there are still pockets of interest scattered over the area that we cover. Favourites of mine are Maldon, Mersea, Hoo, Strood and Faversham. At all of these the possibility of finding barges, smacks and other traditional

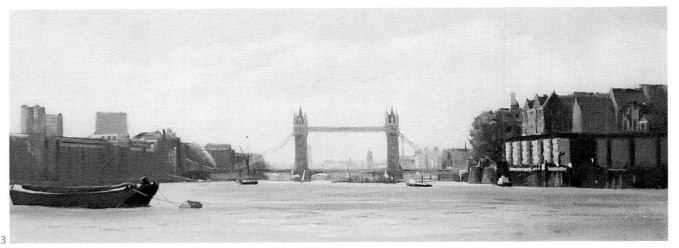

working boats adds to the anticipation on a Wednesday during the season.

Rotherhithe, with its lighter repair yards and wide foreshore, has always been one of the choice venues, and although there are now fewer lighters and modern architecture is displacing the more picturesque, the changes in the weather and evening sun, together with heightened activity at high tide, still draw us.

We are always looking out for new subjects. Recently two visits were made to a boat-building yard near Henley where real craftsmen are producing traditional vessels of top quality. Through the owners' hospitality we were able to take full advantage of a wealth of subject matter.

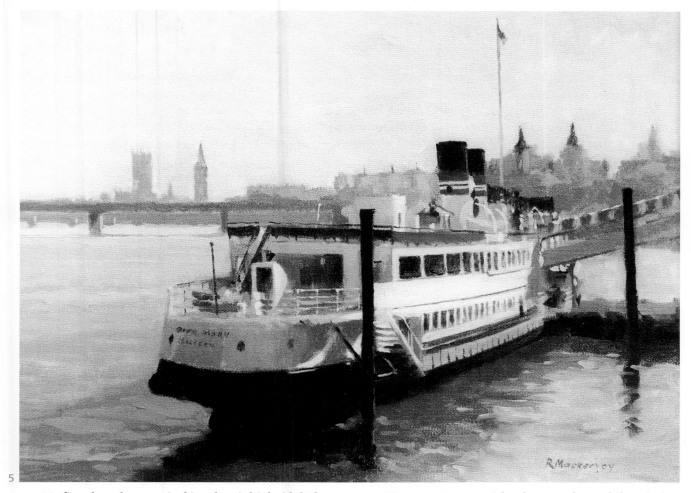

My first thought on arrival is, when is high tide? Then, what direction will I be looking? I carry a compass because the river has many bends and I need to know where the sun will be later if it is not already out. The medium I use could depend on the weather. If it is already raining or will soon, it has to be oils. Otherwise watercolour is an option. The size of painting is influenced by the time available before light fails or the pub becomes more important. The temperature is always lower by the river so adequate clothing is required and a hat is indispensable. I like to start by sketching as a limbering-up exercise as well as to provide information for the future.

We may not meet with other members while painting but at the end of the day we find that they have been scattered over the landscape and conversations over a drink complete the day's entertainment.

1. Evening mooring, Isleworth. Oil 7"x 10"
2. Southwark Cathedral. Oil 14"x 10"
3. Entrance to the city. Oil 12"x 30"
4. Building a slipper launch. Oil 9"x 12"
5. The Queen Mary. Oil 12"x 16"
6. St Paul's Cathedral, Acrylic.15"x 11"
7. Evening delivery, Dartford. Watercolour 9"x 12"
8. Early evening, Strand on the Green. Watercolour 9"x 12"

Ronald Maddox

My early links with the Wapping Group started in the late fifties, encouraged by Rowland Hilder, Jack Merriott and Donald Blake. This was at the time I was elected a Member of the RI in 1959 – the youngest member since its formation in 1831.

I had started painting the Thames at the age of nine. My grandparents lived at Leigh-on-Sea, and staying with them I would look out across the estuary, where there were so many boats to draw, and then in 1939 a view with barrage balloons and vapour trails in the sky after the outbreak of war.

A few years later after grammar school education I was accepted as an art student at St Albans School of Art and at St Martin's School of Art, London. For two years during my National Service in the RAF I was an artist/designer in the Air Ministry Design Unit in London. This enabled me to continue art education at London Colleges for graphic design, illustration and printmaking. Following this I worked as a designer/typographer and as an art director in London art studios and agencies until in 1962 I became freelance. Among the many commissions were illustrations for telephone directories, and quite a number of these featured subjects related to different locations along the Thames, and the sketchbook drawings were often good subjects for future paintings.

Commissioned by the BBC for a series of London lithographs, I had to make a detailed drawing of the Royal Festival Hall with a view from Hungerford Bridge. This created interest from passers-by, and I was joined by a busker playing his violin alongside me. When I

1

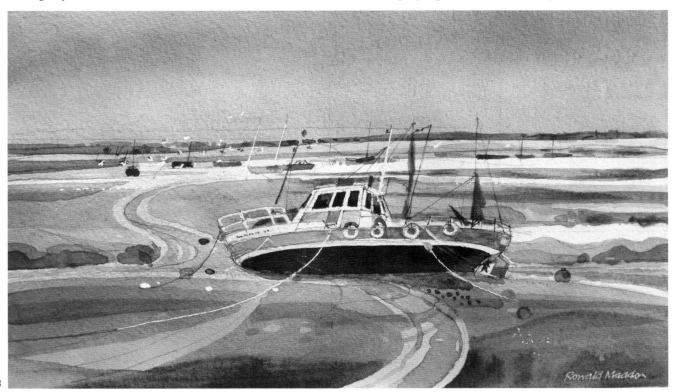

2

3

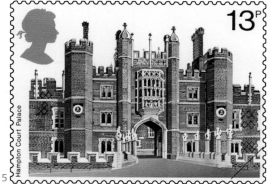

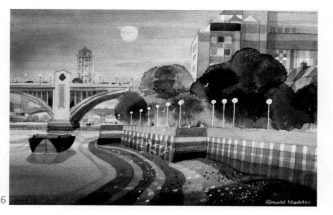

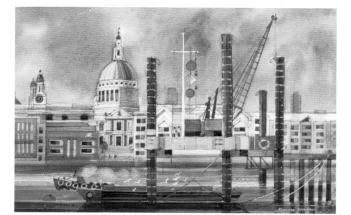

completed the drawing I found that I too had received financial contributions in my drawing case beside me!

I was also one of the designers for the Post Office involved in new issues of commemorative stamps, mainly architectural issues, and these included along the Thames the Tower of London and Hampton Court in a series of British Historical Buildings. There were commissioned paintings for Laing Construction and Mobil Oil, for a series of large watercolours, and alongside these were many illustrations for books, magazines and advertising, all linked with Britain, its landscape and architecture.

As President of the RI, and because of my involvement with other Societies, including the Artist's General Benevolent Institution (AGBI), I find the time available to get along to the Group's weekly meetings is very limited.

1. Shakespeare's Globe, 1997. Watercolour
2. Thames, Lambeth Palace, 1996. Watercolour
3. Estuary, Leigh-on-Sea, 1994. Watercolour
4. Thames, Windsor, 1997. Watercolour
5. Hampton Court Palace, from a series of stamps for the Post Office, 1980
6. Foreshore, Bankside, 2001. Watercolour
7. Construction of the Millennium Bridge, 1999. Watercolour

Edman O'Aivazian

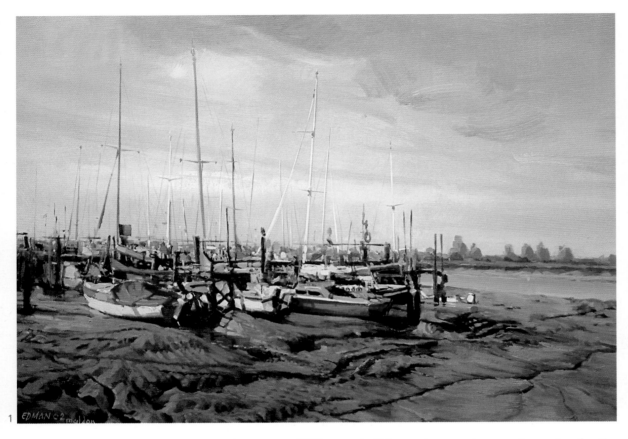

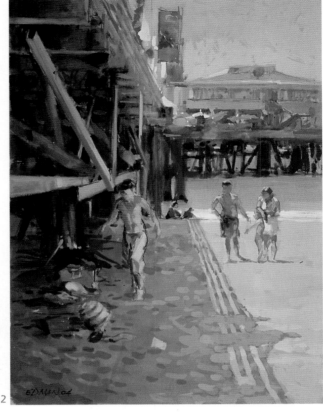

1. The last light of the day, Maldon.
 Oil on canvas. 20"x 27"

2. In the shadow of the pier, Santa
 Monica. Gouache. 18½"x 14"

3. Sailing companions, Putney Bridge.
 Oil on canvas. 18"x 22"

4. Boatyard II, Brentford.
 Oil on canvas. 27"x 20"

5. Pagoda, Battersea Park. Pencil sketch

Born in Teheran in 1931, into an Armenian family, Edman started painting at the age of 13. As a young artist he regularly participated in group exhibitions and one-man shows, exploring and recording that vast country on canvas. His paintings capture the richness of the cultures, traditions and the architecture of past and present. These works culminated in the publication of 'An Armenian Village' in 1984. From an early age, Edman's travels influenced his outlook on art, and in particular classical Rome with its awe-inspiring power led to a series of church murals, including 'The Last Supper' and 'The Creation'. In 1971 Edman moved to London via Rome, where he studied at the Academy of Arts. He paints in oils, acrylic and watercolour.

He has studied Persian art at Isfahan, a cradle of Islamic art and design, and has designed a 250 metre calligraphy frieze, which was installed in Riyadh Airport in 1985. More recently he was commissioned to design a 50-metre mural for the King Abdulaziz National Museum, Riyadh.

His work is founded on the need to understand nature though the abstraction of form, light and colour. Having distilled this essence, Edman has applied his natural talents to capture the diverse scenery of the river in all its forms. He joined the Wapping Group in 2002 and feels very much at home in the company of like-minded painters, enjoying the endearing friendship of his fellow

artists, who are dedicated to recording the essence of the Thames and the human activity that this great river supports on its banks.

In 1977 Edman met Aram Khachatourian in London, and was asked to paint a portrait of the great composer. This painting now hangs in the Khachatourian Museum in Yerevan, Armenia. His works are currently exhibited at Museum San Lazaro, Venice; the National Museum and the Museum of Modern Art, Yerevan; and the Aivazovski Museum, Theodosia. Murals are in the Armenian churches, Teheran and the National Museum, Riyadh.

Exhibited: Biennale Venice, New York, Yerevan, Crimea, RIBA London, ROI, RSMA.

The river as an allegory

In that memorable film *The River of No Return*, Marilyn Monroe and Robert Mitchum floated on a raft down a river with rapids and dangers lurking at every turn before reaching the calm flow in the flatlands where they presumably lived happily ever after. My own life mirrors this allegory, for having moved westwards I have finally settled down by the calm flow of the Thames and have the good fortune to have my studio near Putney Bridge.

Painting on the banks of the Thames, I sometimes think that the eastwards flow of this great river mirrors my yearning for the East and the picturesque nature of Iran from where I started my journey.

5

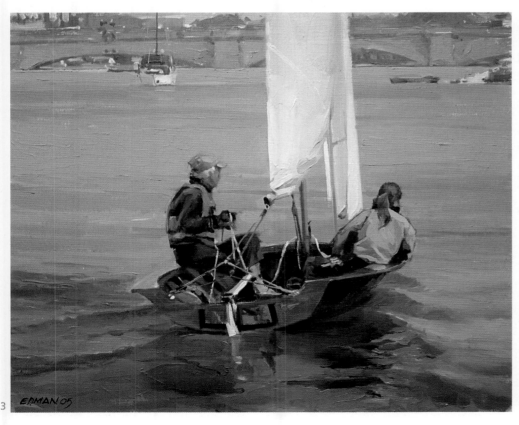

3

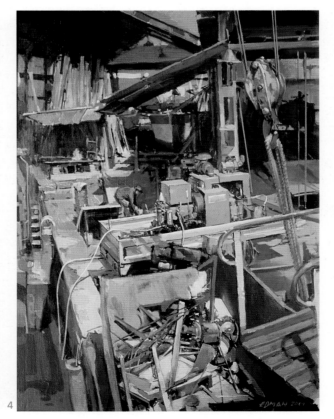

4

Denis Pannett

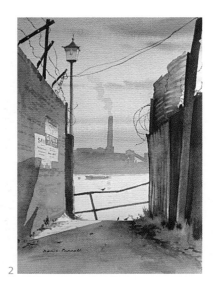

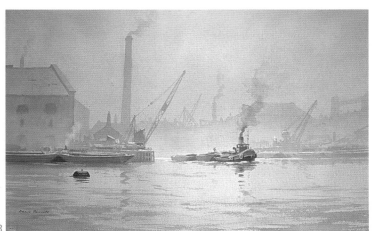

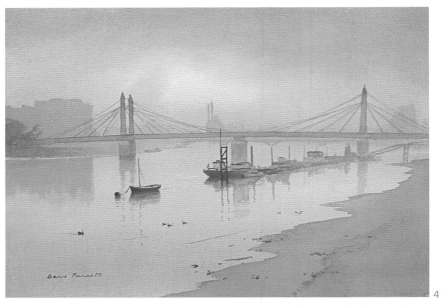

All my life I have been influenced by the powerful images art can produce. Some of my earliest memories are of dramatic, atmospheric illustrations from my childhood books, which filled me with excitement and sometimes fear.

I was brought up in an artistic environment, as my mother was a professional portrait painter, though I never had any intention to become a painter myself. However I was very stimulated by the work of Roy Nockolds (I still have a wartime postcard by him of a Hampden over moonlit water on the wall in my studio), Frank Wootton and Terence Cuneo in the *How to Draw* series, and later by the wonderful pen and wash drawings by Edward Seago in *With the Allied Armies in Italy*, which was the first art book I ever bought with my own pocket money.

Apart from having one painting of a Spitfire exhibited at the Society of Aviation Artists while still at school (this was painted using up my mother's oils left over from a portrait and entered without my knowledge!), I took no real interest in art till when I was in my thirties. The whole family went on an art course at Walberswick with Edward Wesson and from then on I was inspired by his mastery of simplicity, tone and colour.

I started exhibiting in local galleries and the London exhibitions and in 1975 was elected a member of the Guild of Aviation Artists, followed in 1979 by being made an honorary freeman of the Painter Stainers Company. By 1982 I found I had more art work than I could cope with, so resigned from De Beers, with whom I had been for twenty years, and went full time into art.

For almost twenty years my mother, aunt and I ran art courses in Sussex and enjoyed numerous overseas painting trips, even having two exhibitions in Hong Kong. In 1984 Gordon Hales who had seen my work at an exhibition in Berkhamsted, approached me to ask whether I would be interested in submitting paintings with a view to

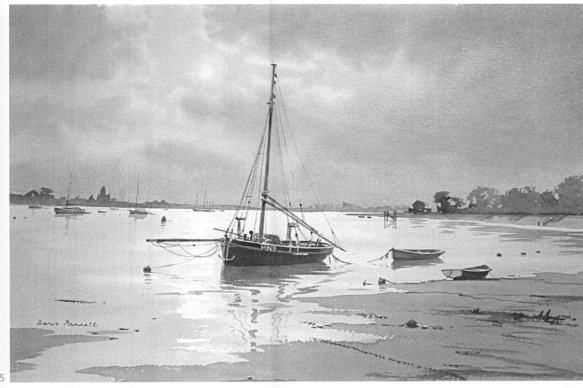

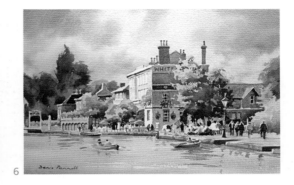

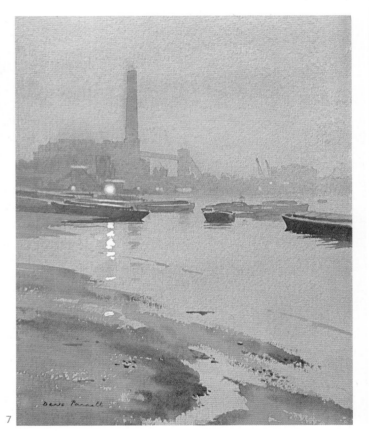

candidature for the Wapping Group and I was delighted to take up his offer as I had always admired the Group. I was fortunate enough to be elected a member in 1985.

My first Wapping meeting was at Greenwich and I rather nervously sat and painted next to Ashton Cannell. He soon put me at my ease by saying 'Have you ever tried Aureolin Yellow? It's a wonderful colour,' and he then proceeded to squeeze the tube onto my palette. The ice was broken and from then on I have always enjoyed the wonderful friendship of the members, though sadly neither Gordon nor Ash is still with us.

We have had great times together, not only on the Thames mud banks but also following the barge matches, sailing to Calais, painting as a group in France and even at the wheel of the wonderful steamboat VIC 56 sailing up to Tower Bridge – all very inspiring!

1. Autumn evening, Battersea.
 Watercolour 13"x 21"

2. Greenwich sparrows.
 Watercolour 14"x 10"

3. Leaving Deptford Creek.
 Watercolour 13"x 21"

4. Evening, Albert Bridge.
 Watercolour 10"x 14"

5. The oyster smack, Maldon.
 Watercolour 13"x 21"

6. The White Cross, Richmond
 Watercolour 10"x 14"

7. Dusk at Greenwich.
 Watercolour 21"x 13"

David Penny

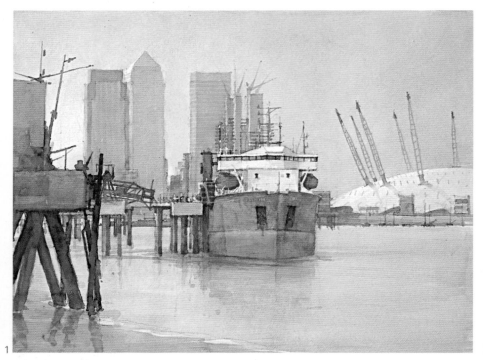

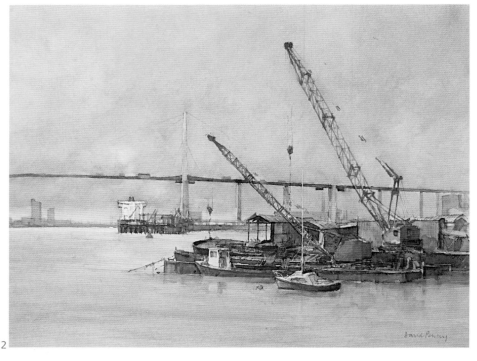

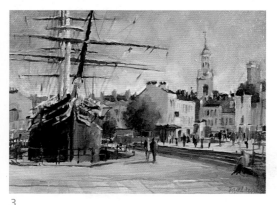

I studied and worked in architecture till the early 1990s, latterly in County Hall, using free drawing as part of my work. I took relatively little notice of the rich variety of artistic material a stone's throw away; indeed I was often glad to get out of London at the end of the working day. The recession led to redundancy, a blessing in disguise. Almost by chance I started sketching, painting in watercolour and sometimes oils, and became an active outdoor participant with Farnham Art Society, learning to see and discovering the pleasure of working outside. Strangely, a demand for architectural illustrations started at the same time.

I became familiar with the Wapping Group and its work on the Thames, realising what I had missed for all those years. My year as a candidate was a delight and a source of stimulation and motivation, working in wonderful locations in the company of established and very able painters, all most companionable. I was honoured to become a full member in 2000.

One of the principal aims of the Group is to record the life and spirit of the river. I do tend to look for 'moments in time' when selecting subjects, though I will be tempted by the more timeless subject matter still available. It doesn't matter too much to me if people are around when painting (though the South Bank is impossible if the tide is up) but I am wary of 'I'm an artist too...'

I try for structured compositions, probably due to my architectural background, and buildings are often present. Much of the development now going on is pretty awful but I feel the need to at least consider if it can be used. The vagaries of the weather and working by water mean that glazes can take time to dry so my target is to draw fast, get the feel and mood down and finish off in the studio if necessary – photos can be useful for this, but I've not had

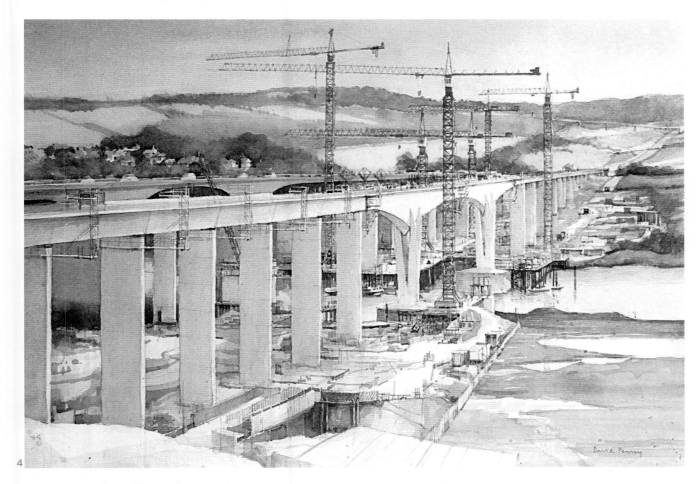

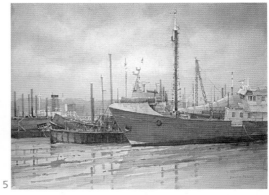

a camera yet that will record atmosphere.

At the end of the day there is the welcome prospect of an evening in a nearby pub when you can find out just where some have been hiding and perhaps what they've found to paint.

A bonus has been to be part of Group trips to the Loire, St Malo, Honfleur, Bruges and so on – excellent painting locations combined with good company, food and perhaps the odd drink.

It is an eagerly anticipated privilege to exhibit with the Group in the close season and see that its principles hold true even in these commercial times. Long may it continue.

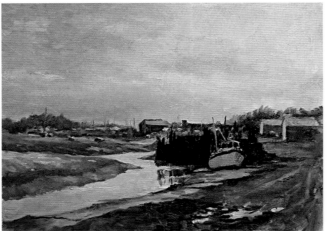

1. The *Westminster* at Bugsby's Reach.
 Watercolour 13"x 17"
2. The QE2 Bridge from Greenhythe.
 Watercolour 13"x 17"
3. The *Cutty Sark*, Greenwich.
 Oil 8½"x 11½"
4. Eurolink over the Medway.
 Watercolour 20"x 29"
5. Rain clearing at Hoo.
 Watercolour 13"x 17"
6. The Eye. Watercolour 20"x 26"
7. Sundown, Leigh-on-Sea.
 Oil 8½"x 11½"

John Powley

The smoke, tugboats, cranes and wharves which inspired Whistler and gave so much scope to the early Wapping artists have been replaced by a hotchpotch of architectural showpieces. But these can make dramatic backdrops to river scenes and the rejuvenated South Bank provides many tempting viewpoints now from Battersea to the barrier with Southwark and Greenwich on the way.

I find the Thames seductive but intimidating with its huge tides and peculiar silvery mud which sticks to shoes like aluminium paint. The far bank is too distant and the near is surmounted with by parapets above easel height. There is an occasional gap opposite slippery steps where a noisy concourse of traffic and pedestrians trundles incessantly behind one's back. Yet although the Wapping Group paints further afield on the Medway, Blackwater, Colne and Upper Thames, London still remains an inexhaustible challenge. John Virtue's superb exhibition at the National Gallery (2005) attests to this.

When painting in town I insist on maximum comfort without being too obsessed about the view. A sheltered hidey-hole under a bridge or in a shop doorway will do,

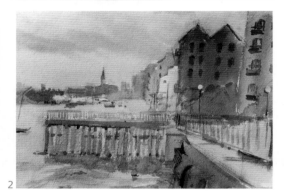

1

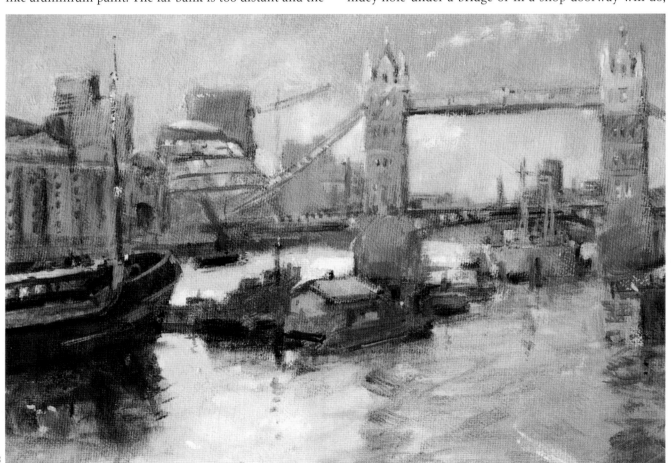

2

3

1. Low tide at Bermondsey. Watercolour 11"x 15" on 200lb Saunders Waterford (Not) paper, looking west towards Butlers Wharf and Tower Bridge.

2. Wapping Wall. Gouache 11"x 15" on 200lb Two Rivers (Not) paper. The Prospect of Whitby pub is just visible sandwiched between modern flats replacing the old warehouses.

3. Tower Bridge and Upper Pool. Oil 10"x 15". A popular view from St Katharine's Way. Ken Livingstone's beehive (City Hall) had just been built.

and a subject nearly always presents itself, just as in Venice. Sometimes I look across the Thames nostalgically to King's College next to Somerset House. When I was a medical student I used to commute daily by tram to King's, where we dissected bodies on the top floor; learning anatomy was helped a little by being able to draw. Now I live in Eastbourne where the Downs make a peaceful contrast to the 'Great Wen', although they are quite bland and subtle to paint. However, successful painting entails contrast and counterchange: no greater than when travelling by train via Firle Beacon and the Long Man in Sussex to the hurly-burly of London past that sensational view over the rooftops at Battersea Park.

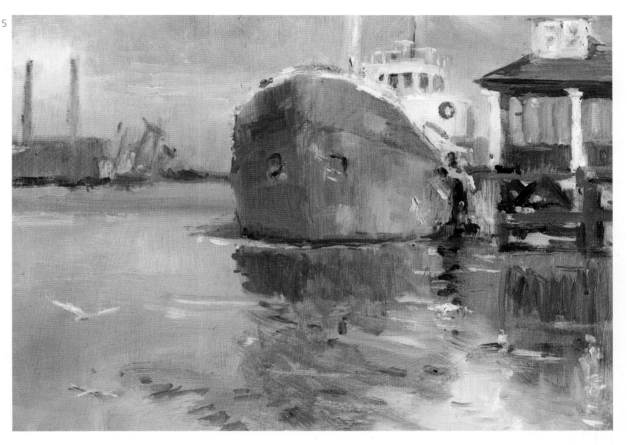

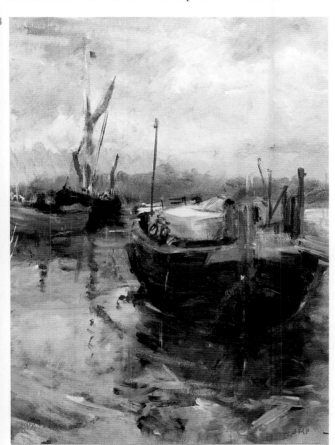

4. Derelict barge at Pin Mill. Oil 20"x 18". The Orwell at high tide, as seen from the Butt and Oyster.

5. Cargo boat at Gravesend. Oil 10"x 12". Painted using a pochade box while seated at the ferry station for Tilbury.

6. Houseboat chores at Battersea. Oil 10"x 12". Looking across to Lots Road power station from Old Swan Wharf on a hot day. I was so glad the flowers needed watering. Developed from a rapid and furtive pencil sketch.

Michael Richardson

As a child I was always drawing and for hours I would often doodle aircraft and ships – these would have to have the key features to make a Spitfire unmistakeable and so on. Similarly, as my sister was an enthusiastic horsewoman, the anatomical accuracy of a Stubbs was crucial, but elusive, when attempting horses. At art school drawing and life classes were plentiful, together with sculpture and pottery diversions. The painting I then particularly admired included the works of Utrillo and Manet, the Americans Homer, Wyeth and Whistler, and the loose watercolour of John Singer Sargent. After a couple of pleasant years I was

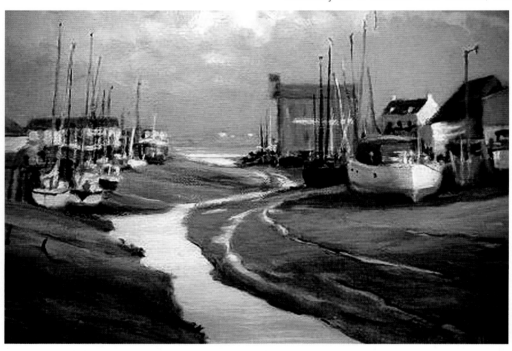

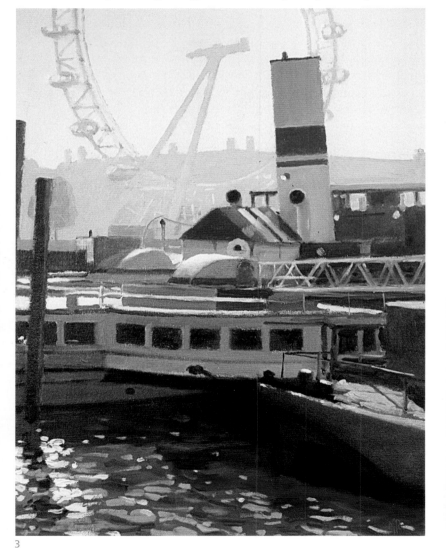

1. Faversham Creek. Oil
2. Calm morning, Battersea Reach. Watercolour
3. *Tattersall Castle* and the Eye. Oil
4. Thamesport cranes. Watercolour
5. Embankment strollers. Watercolour
6. Laying up, Faversham. Oil

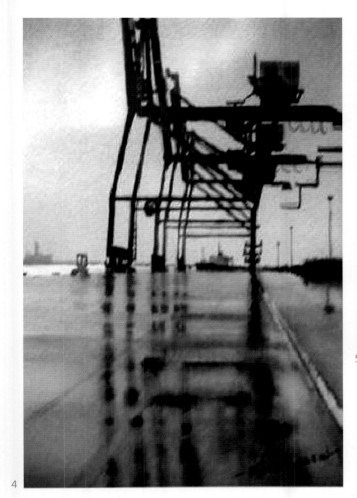

4

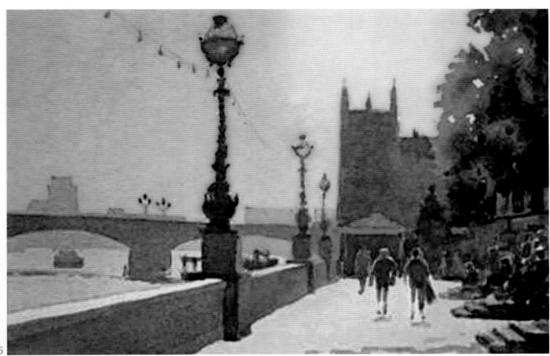

5

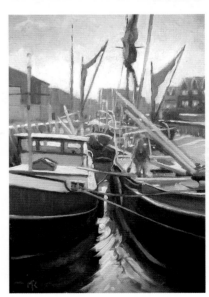

6

lured away by business, being aware that such a genius as Van Gogh had only sold one work in his lifetime (to his brother).

Twenty-five interesting years later, having also indulged my passion for dinghy and yacht racing, I returned to serious painting, and began working outdoors, ruining many shirts as I became familiar with oil pochade boxes and the challenge posed by inquisitive flies and the weather.

I became familiar with the Wapping Group and its aims and work, and was honoured to be elected to membership in 1998. It was an immediate pleasure to work and socialise with such a respected and convivial

Group in most varied and stimulating locations on and around the Thames.

New challenges of tidal waterside painting arose, particularly with the tendency of water and boats to rise or fall during a painting session, and also the reluctance of watercolour to dry, which prompted a rather wetter approach. The beauty of working outside is the spontaneity and freshness of getting the subject and mood, and perhaps catching that fleeting moment of magic caused by the changing light.

The Group exhibitions show much evidence of the freshness of the *en plein air* origins of paintings, and it is a privilege to take part in them.

Whilst the Group paints and exhibits together, each active member also contributes by helping run the Group affairs – because of my background I was, not unwillingly, appointed to steward and nurture the Group's finances. No problem really, but just who was it that quietly slipped me their sub in used notes as I left the pub in mellow mood last evening after another great day by the river...?

Alan Runagall

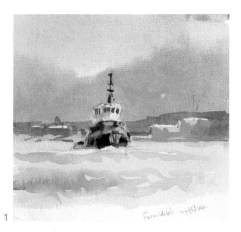

When I started work for the Port of London Authority in the old ledger office at West India Docks in September 1957 I did not realise how it would affect my life. I had always loved ships, and particularly Thames barges, which had fascinated me since I was a young lad, when I would watch them working their way up to Rankins flour mills at Stambridge near my home. So to work for the PLA was a dream come true. Although the office work was rather mundane I loved the hustle and bustle and the atmosphere of the docks. At lunchtimes I would wander along the quays and wharves, taking in all of the activity and enjoying being part of that atmosphere. I had always loved drawing and painting so I began to sketch the ships, lighters, tugs and other small craft. Little did I know then, that in thirty or so years time I would call on all of these observations and experiences to paint seriously as a member of the Wapping Group of Artists.

I remember one lunchtime in particular; I was passing the western end of the South West India Dock, and saw the famous old sailing barge *Cambria* moored with a cargo of fishmeal. It was very rare to see a working Thames barge in the docks as late as the 1950s so I quickly started to draw her. But within a few minutes a small tug came up, hitched onto *Cambria*, and promptly towed her up the dock to the lock at the far end. This image stayed with me

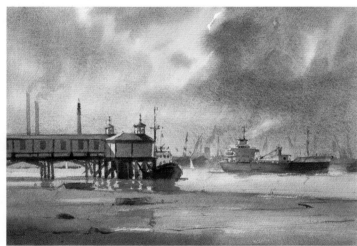

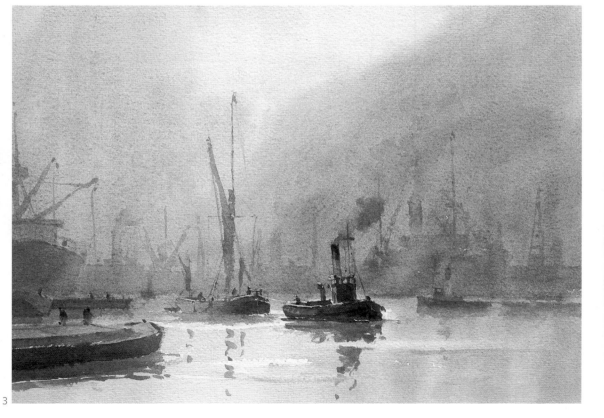

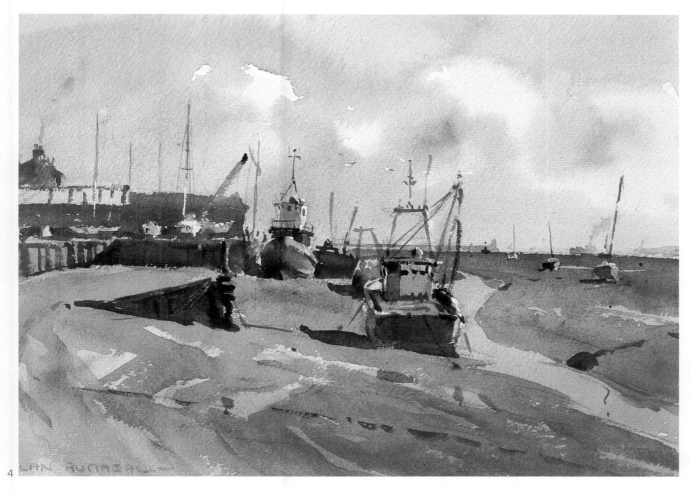

and in 2004 I did a painting of this memory which I exhibited in the RSMA exhibition at the Mall Galleries (see 'A Helping Hand'). I changed the viewpoint and made a few other alterations to make an interesting picture, but the idea was nearly fifty years old!

Later, because the upper docks were closing down due to the advent of the container ship, I transferred to Tilbury, where I continued to paint the dockland scene and in particular the river. By now I had started to paint 'watercolour' sketches instead of 'pencil', and most of these were done in under thirty minutes. I found this quick way of working very satisfying and rewarding and I think that is how my style developed. I like to think that my paintings look fresh and lively as a result of this approach. In 1987 I was made a member of the Wapping Group of Artists and a whole new painting world was opened up to me; visiting Thames-side venues even I was not aware of, and going much further afield to paint such places as Whitstable and Faversham in the east, and Richmond and Windsor in the west.

1. Sun tug *Formidable*.
 Watercolour 4½"x 5"

2. Thames traffic off Gravesend.
 Watercolour 10½"x 14½"

3. A helping hand.
 Watercolour 10½"x 14½"

4. Low water, Leigh Creek.
 Watercolour 10½"x 14½"

5. Houseboats at Chelsea.
 Watercolour 9½"x 6½"

John Worsdale

Grandad Jim Parker of Custom House was employed as a docker in 'the Royals' when he was lucky enough to 'catch the foreman's eye' or maybe could find the price of a pint for the foreman's favourite tipple, in the casual employment system of the day. I don't imagine old Jim found much romance in the struggle to earn a crust in his rough, tough world, and could he but know would have surely found it strange that his grandson should seek out some of those London River locations to romanticise in paint.

I was born at Southend in 1930 and we lived within 100 yards of the river which turned out too close when the 1953 flood left a 4-foot depth of the 'liquid history' in our house.

In the early days, when information on 'ships passing the pier' was displayed at the seaward end of Southend Pier (vessel's name, shipping line, tonnage, inward or outward bound, destination), we youngsters were well aware of our then busy river.

Venturing further afield to Stambridge Mill on the River Roach, or Battlesbridge on the Crouch, the sight of one or more of our dear old Thames barges would delight us, and even more barges were seen on my first visit to Maldon, a Sunday-school outing in 1938.

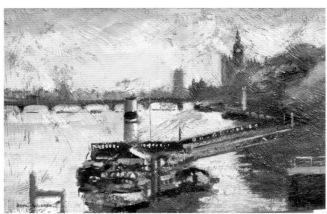

Much later and myself a new Wapping Group member, six of us met on a number of occasions to stay on the late Charles Smith's (Group President 1987 – 1992) barge *Leslie West* moored at Pin Mill on the River Orwell. Over a weekend, sometimes longer, we would paint away at that home for barges, now alas just a few hulks left and no longer the several fully rigged seaworthy craft that we knew.

In those times too I witnessed a number of barge matches on the Rivers Blackwater, Medway and Thames from a following boat. On one match a TV cameraman came aboard our boat and I had the pleasure of seeing a watercolour sketch which I had been making shown that evening on the screen.

Although not starting into 'serious' painting until the age of 35, drawing was always of great interest, attracting me to employment as an engineering draughtsman, initially under the ridiculous notion that it was something to do with drawing! Nowadays, when painting is such a large part of my life, I continue to view good drawing as a strong underlying basis (and with this the painting's design or composition), however much freedom is allowable in the application of paint.

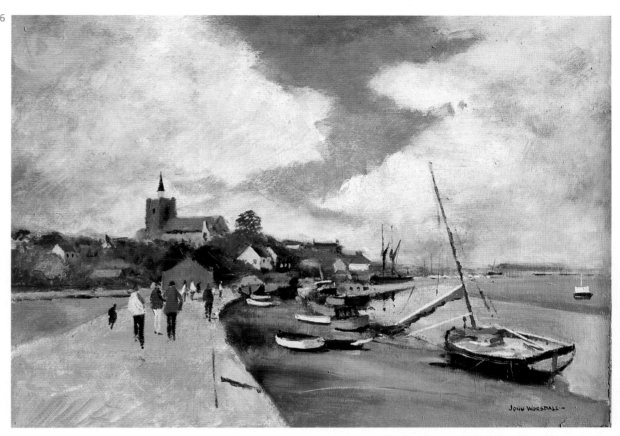

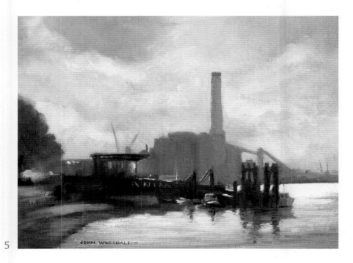

Having painted many thousands of watercolours over the years, oils for me are assuming 'pole position' – much easier than watercolours! Here is the chance to end on a controversial note providing scope for a little banter with my Group comrades.

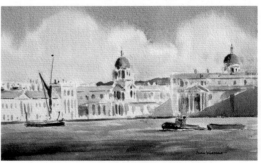

1. Sketching at Strood.
2. Light and shade, St Katharine's Dock. Acrylic 10" x 13½"
3. Leigh shrimpers. Watercolour 10" x 14"
4. PS *Tattershall Castle* and Westminster. Acrylic 7½" x 12"
5. Greenwich pier and Deptford power station.
 Oil 11½" x 15½"
6. Maldon Promenade. Oil 16" x 21½"
7. A breezy day, Greenwich. Watercolour 6¾" x 10½"

Bert Wright

I joined the Wapping Group almost 30 years ago and in that time have seen many changes taking place to London and the River Thames. The commercial shipping that existed has now disappeared from the upper reaches of the river. What has not changed in that time however is the unique nature of the Wapping Group, who have remained a dedicated band of artists painting along the banks of the Thames and in the streets of London. In my career I have been an illustrator, manager of a design and illustration studio and general manager of the Scenery Group of the BBC.

During those years I continued to paint and exhibit my own work. This held me in good stead when I decided

to return to painting full time in 1980. Despite an initial financial setback it was a decision I have never regretted.

The independence I now had enabled me to travel extensively and paint in many places around the world, including the Middle and Far East. My principal location is America, where I now have an association with a number of galleries. For the past twenty years I have been painting mainly marine subjects along both coastlines of America. On return I look forward to joining the Wapping Group painting sessions along the river. The sense of being outdoors, achieving one or two paintings during the day, and adjourning to a pub late evening for a get-together with other members, is a pleasure.

I have always admired the Wapping Group in the manner it selects its members. Clearly they have to be outstanding artists, particularly as outdoor painters, but they also have to fit into the camaraderie which has always

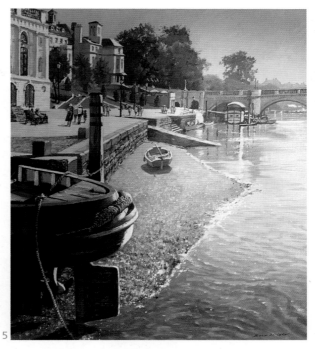

been an essential element of the Group.

I am fortunate in living near to reaches of the Thames such as Strand on the Green, Old Isleworth and Richmond.

These particular subjects have changed very little over the years and have provided inspiration for many famous artists. I personally enjoy the river at low tide either early morning or late evening. Achieving the effect of reflected light on a muddy river bank is inspiring, believe me! Changing light and seasons provide an endless source of subjects for me to paint. Long may it continue.

1. Reflections. Oil 12"x 16"
2. Strand on the Green. Watercolour 14"x 21"
3. Boatyards, Rotherhithe. Oil 20"x 30"
4. Upper Pool, London. Oil 24"x 32"
5. Fine day, Richmond. Oil, 30"x 26"
6. Slipway at Chiswick. Watercolour 10"x 14"

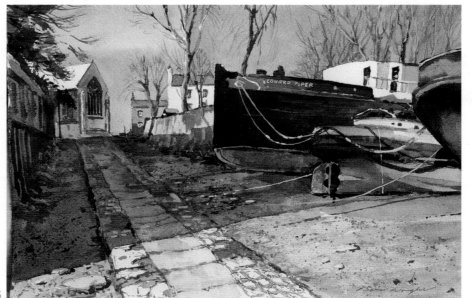

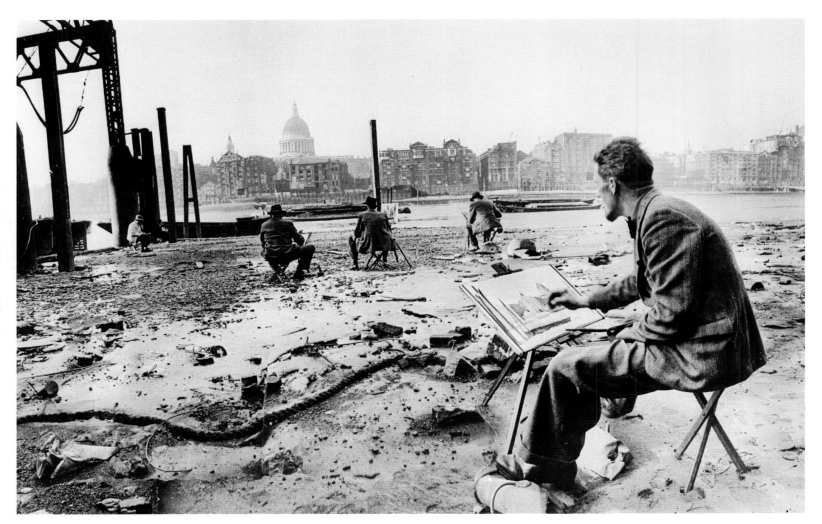

Low tide at Bankside, 1947. Jack Merriott in the foreground (*Picture Post*, 16 August 1947). Photograph © Hulton Getty

IV
A gallery of past members' work

Since the beginning, there have been in all ninety-six members of the Wapping Group, and twenty-four of those are current members whose work appears in the preceding pages. Space does not permit us to illustrate all the remaining seventy-two, but the following pages present a fair selection, and still others can found in earlier sections of this book.

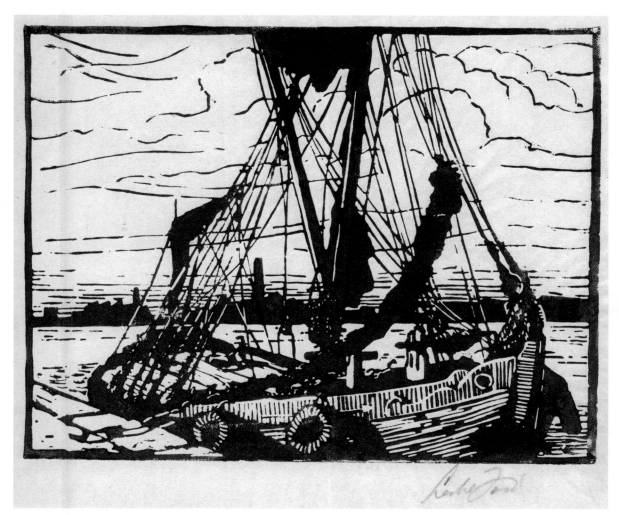

▶ Linocut of a Thames barge by founder member Leslie Ford

George Ayling

Leonard Bennetts

George Ayling with a finished painting in front of his subject.
Photo © Desmond O'Neill

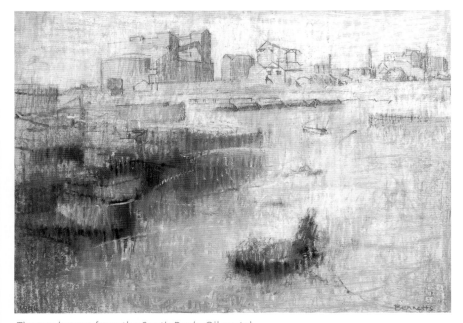

Thames barges from the South Bank. Oil pastel

Donald Blake

Hugh Boycott Brown

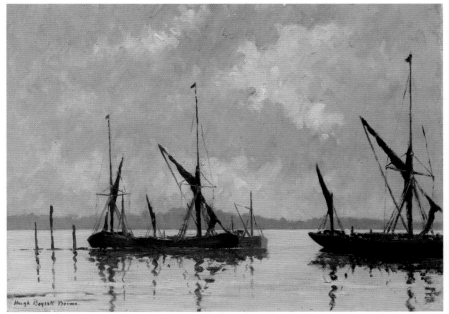

Greenwich. Pen, ink and wash. By courtesy of Lincoln Joyce Fine Art, Great Bookham

Approaching storm, Pin Mill. Oil. RSMA Diploma Collection

Arthur Burgess

John Davies

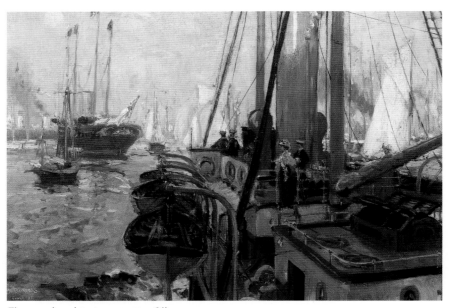

The royal yacht at a regatta. Oil

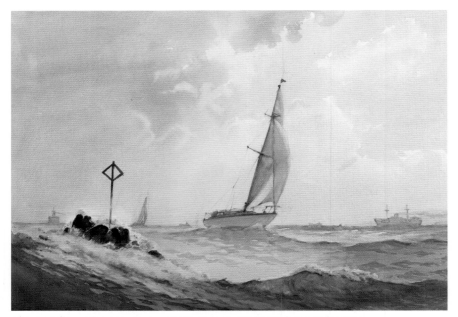

Ebb and flow, Thames estuary. Watercolour. RSMA Diploma Collection

Vic Ellis

Roger Fisher

Barking Creek, Essex. Oil

Spray. Oil. RSMA Diploma Collection

Sydney Foley

Evening, Isleworth. Oil

Wilfred Fryer

Unloading whelks, Norfolk. Watercolour. RSMA Diploma Collection

Peter Gilman

Roy Glanville

River bank at Richmond. Barges. Oil

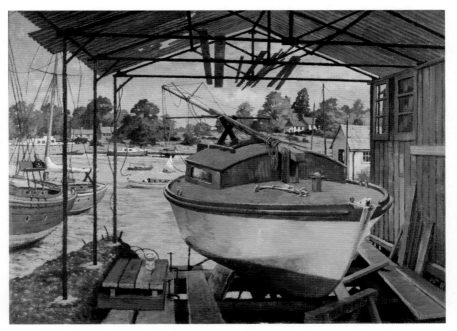

Awaiting high water. Oil. RSMA Diploma Collection

David Griffin

Gordon Hales

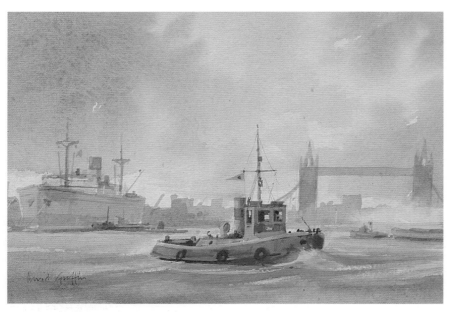

Tugs at Tower Bridge. Watercolour

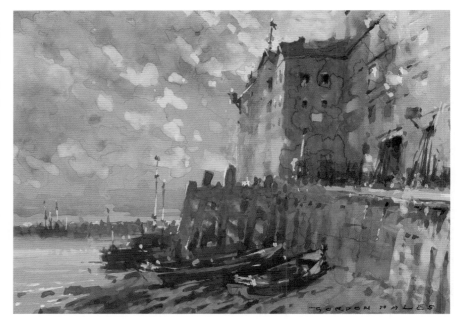

Old Rotherhithe. Gouache

Rowland Hilder

Leslie Kent

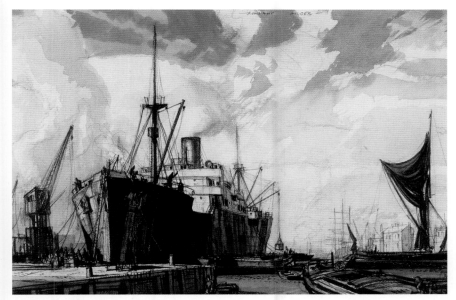

Pool of London. © Estate of Rowland Hilder (photographed by Rado Klose)

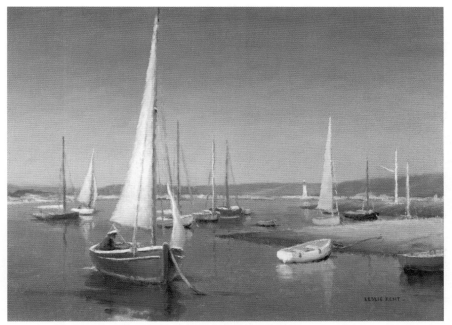

At Keyhaven, Hampshire. Oil. RSMA Diploma Collection

Jack Merriott

Eric Thorp

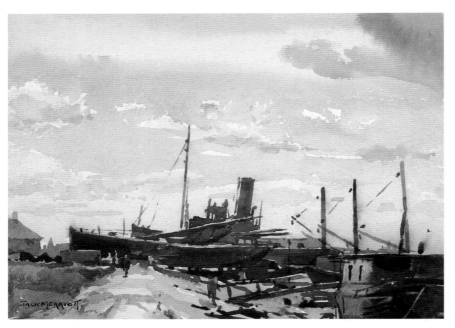

Gravesend. Watercolour

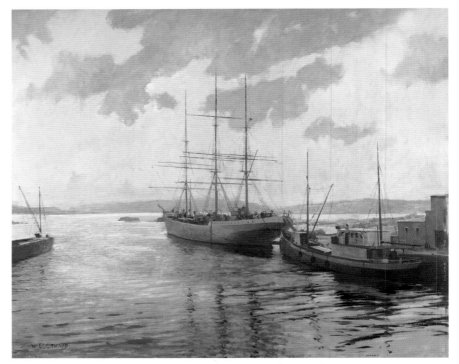

Training ships at Kristiansand, Norway. Oil. RSMA Diploma Collection

Sydney Vale

William Watkins

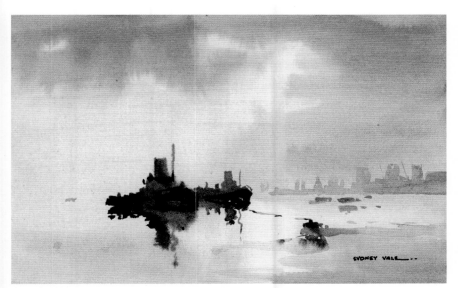

Tugs. Watercolour

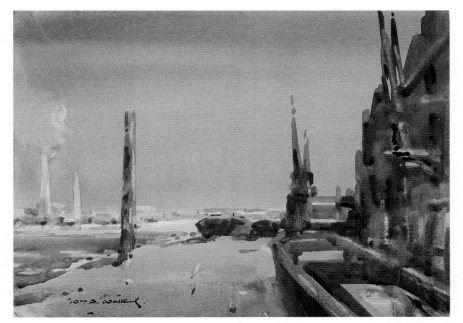

Wapping, low water. Watercolour

Edward Wesson

Leslie Wilcox

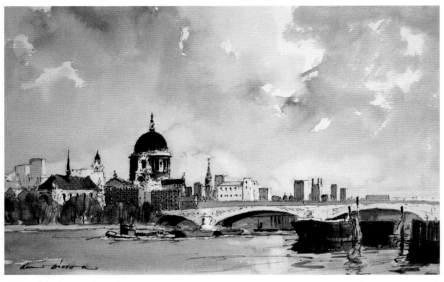

St Paul's. Line and wash

Start of the Tall Ships Race. Oil. RSMA Diploma Collection

Appendix
Members of the Wapping Group 1946 – 2005

Dates shown are years of membership
**Founder member*

ALDRIDGE, R. de Winton, FRIBA	1976 – 1985	CANNELL, Ashton, RSMA, ATD, UA	1971 – 1994
ARGENT, Charles	1959 – 1973	CARDEW, Sidney, RSMA	1990 –
AYLING, George, RI, SMA	1953 – 1963 President 1960	CHAMBERLAIN, Trevor, ROI, RSMA	1969 – President 1998 – 2003
BACKHOUSE, Bill	1949 – 1951	CLARKE, T. F., FRSA*	1946 – 1955
BANNING, Paul, RI, RSMA	1995 –	COTTINGHAM, Grenville, RBA, RSMA, ATD	1991 –
BECKETT, Fred, Hon RI, Hon RBA	1998 –	DAVIES, John A., RSMA	1968 – 1984
BELCHER, Frank	1958 – 1960	DAVIES, William	1974 – President 2003 –
BELL, F. A.*	1946 – 1953	DELLAR, Roger, RI, PS	1996 –
BENNETTS, Leonard, DFA	1996 – 2004	DENHAM, Henry, SMA, SGA*	1946 – 1962
BLAKE, F. Donald, RI, RSMA	1963 – 1989 President 1982 – 1987	DRUMMOND, C. H. *	1946 – 1954
BOND, Arthur, SMA*	1946 – 1958	ELLIS, Victor, RSMA	1970 – 1984
BOWERMAN, Bernard, FRSA	1954 – 1970	FISHER, Roger, RSMA	1984 – 1992
BROWN, Hugh Boycott, RSMA	1954 – 1990	FLEMMING, Anthony	1990 –
BRUNWIN, David	2001 –	FOLEY, Sydney, ROI, RSMA	1979 – 2001 President 1 2 – 1997
BRYCE, John, GAvA, SWE	2003 –	FORD, Leslie*	1946 – 1959
BURGESS, Arthur, RI, ROI, RBC, VPMA *	1946 – 1954	FORD, Marcus	1967 – 1974

FRYER, Wilfred, RI, RSMA*	1946 – 1968	President 1961 – 1968
GHILCHIK, David, ROI	1963 – 1972	
GILMAN, Peter	1977 – 1984	
GLANVILLE, Roy, RBA, RSMA	1963 – 1967	
GRIFFIN, David	1992 – 2002	
GROOM, Emerson, ARE	1950 – 1972	
HALES, Gordon, RBA, RSMA	1982 – 1997	President 1997
HALEY, H. J.*	1946 – 1960	
HAMLYN, Martin*	1946 – 1967	
HAMMOND, A. V. , RGI	1956 – 1992	
HAMMOND, Roy	1993 –	
HANCERI, Dennis, RSMA	1971 –	
HILDER, Rowland, OBE, PPRI, RSMA	1950 – 1972	
HOFLER, Max, FRIBA*	1946 – 1961	
HOUGHTON, A. B.	1970 – 1998	
HUNT, Geoff, PRSMA	2003 –	
JOBSON, Pat, SMA, SGA, PS*	1946 –	President 1977 – 1982
KENT, Leslie, RBA, RSMA, MICE*	1946 – 1980	
LANG, E., RMS	1953 – 1959	

LEATHART, Julian, FRIBA, SGA	1953 – 1965	
LEECH, G. W.	1947 – 1950	
LYNCH, Hugh	1959 – 1971	
MACKERVOY, Robin	1992 –	
MADDOX, Ronald, PRI, Hon RWS, Hon RBA	1966 –	
MERRIOTT, Jack VPRI, ROI, RSMA*	1946 – 1968	President 1946 – 1960
MIDDLETON, Alan, ARIBA	1954 – 1978	
MIDDLETON, James C., AMC*	1946 – 1969	
MOLD, Allen, RI, PS	1958 – 1965	
MORDEN, W. G., RI	1953 – 1969	
MORGAN, Ronald, ROI, RBA	1986 – 1991	
NEEDELL, Philip, SGA*	1946 – 1953	
O'AIVAZIAN, Edman, RSMA, AROI	2001 –	
PANNETT, Denis, GAvA	1985 –	
PARKER, Cyril, RI	1962 – 1983	
PENNY, David	2000 –	
PENTON, Howard, SMA*	1946 – 1960	
PITCHER, N. Sotherby, RSMA	1950 – 1968	
POWLEY, John	2000 –	

RALPHS, Harry	1967 – 1980	
REDDELL, Harry	1964 – 1991	
RICHARDSON, Michael	1998 –	
RILEY, Harry, RI	1962 – 1966	
RUNAGALL, Alan, RSMA	1987 –	
RUSSEL, A. S.	1956 – 1963	
SHEPPARD, Raymond, RI*	1946 – 1958	
SMITH, Charles, UA, FRSA	1973 – 2003	President 1987 – 1992
STURGEON, Josiah, RSMA, RI, FRIBA	1956 – 1999	President 1972 – 1977
SWANN, Edward	1963 – 1967	
SYKES, Aubrey, PRI, PPS	1963 – 1995	
SYRETT, Dennis, PROI, RSMA, ARBA	1994 – 1999	
TAYLOR, Albert	1963 – 1991	
THORP, W. Eric, RSMA, PS*	1946 – 1992	President 1966 – 1972
VALE, Sydney	1972 – 1991	
WARMAN, Oliver, RBA, ROI	1988 – 1989	
WATKINS, William, RI*	1946 – 1965	
WESSON, Edward, RI, RSMA	1958 – 1960	
WHEELER, John	1956 – 1970	
WHITE, W. Browning	1953 – 1965	
WILCOX, Leslie, RI, RSMA	1956 – 1963	
WILSON, H. J.	1947 – 1956	
WINBY, F. C., FRSA *	1946 – 1958	
WORKMAN, Harold, RBA, ROI, RSMA, RCA	1966 – 1968	
WORSDALE, John	1974 –	
WRIGHT, Bert, PPRSMA, FRSA	1976 –	

The Wapping Group also has an Honorary Membership category, but in almost every case this has been awarded to full painting members who for one reason or another were unable to continue painting. The single exception to this was Ernest King, Hon. Member 1957 – 1994, a staunch friend and supporter of the Group, who was never a painting member.